SKETCH CARD MANIA

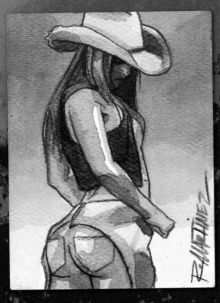

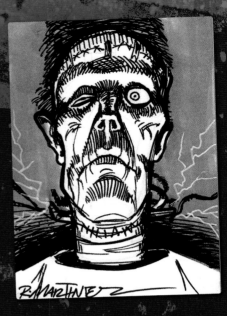
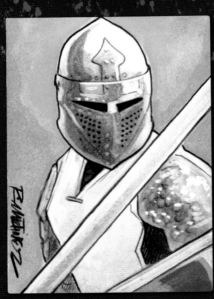
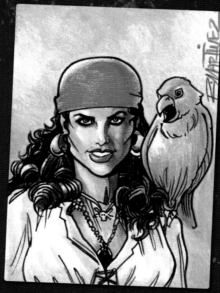
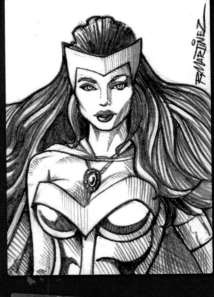
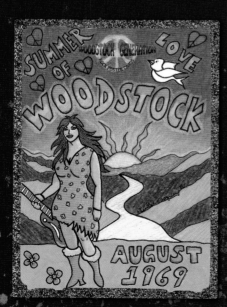
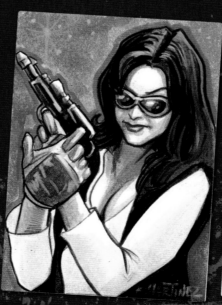
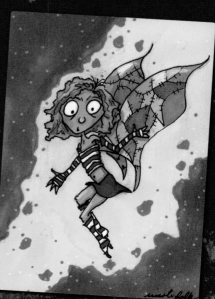

Sketch Card MANIA

How To Create Your Own Original Collectible Trading Cards

Randy Martinez &
Denise Vasquez

IMPACT
CINCINNATI, OHIO
www.impact-books.com

Table of CONTENTS

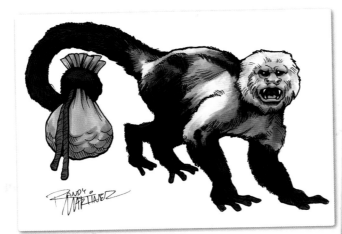

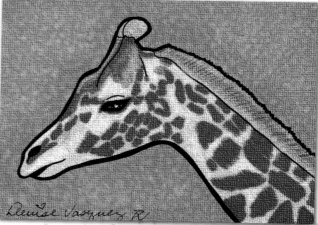

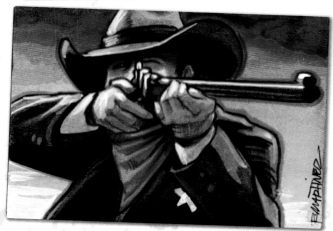

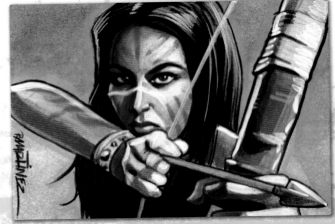

What You'll Need for This Book

Pencils
Use an assortment of graphite pencils for sketching and drawing. Pencils come in a variety of hardness (H graded) and blackness (B graded). A standard no. 2 or HB pencil falls right in the middle and is great for creating sketch cards.

Erasers
Keep a sampling of erasers nearby when you are sketching. A gray kneaded eraser is soft and gentle on paper and can pick up most lines. A white or pink eraser is best for dark lines.

Paper
Choose a paper that's appropriate for the medium you're working with. For sketch cards a sturdy bristol paper works well for most media. You can get full-sized paper and cut it yourself to 2½" × 3½" (6cm × 9cm). Pre-cut artist trading card packets of various types of paper are great for practice.

Cutting and Mounting Tools
To cut and mount your sketch cards you need newspaper, spray adhesive, a rotary trimmer and a ruler.

Colored Pencils
There are three types of colored pencils you can use to color your sketch cards.
- ▶ Wax-based are the most common. You can vary the pressure you place on them to get a smooth, even cover, or to blend with other colors.
- ▶ Oil-based pencils are slightly harder than wax-based and apply in a drier fashion. They tend to break less than wax-based pencils.
- ▶ Watercolor pencils are water-soluble. The pigment dissolves on paper when water is applied, acting much like watercolor.

Black Pens and Markers
You will need black pens and markers to ink your sketches and create clean lines. Permanent black markers are great because the ink won't bleed or mix with other media. Try out different pen tip sizes to learn how to vary your lines.

Colored Markers
Build up a collection of a variety of permanent markers. They provide rich, vibrant color that won't fade over time. Water-based markers are OK, too. They may not be as rich in pigment, but they don't have the strong odor that accompanies permanent markers.

Acrylic Paints
Acrylic paint dries really fast, which is its greatest strength for coloring sketch cards. (Oil paint dries very slowly, which is why it's a big no-no for sketch cards.) Acrylic paint varies in fluidity and viscosity so you can make it thick like oil paint or thin like watercolor.

Watercolor Paints
You can get beautiful effects with watercolor. It dries quickly and you can vary a color's strength by how much water you add.

Brushes and Palette
An assortment of flat and round brushes sizes 2 to 10 work well for the small work area of a sketch card. Small round brushes are essential for painting fine details in your paintings. Angled flat brushes will give you better control in corners. Flats are good for laying in large areas of color, such as watercolor washes. To mix your paints, you'll need a palette with a mixing area and spaces to separate your paint colors.

Mixed Media
Dress up your sketch cards with all different types of art materials: beads, feathers, sequins, ribbon, glitter, gel pens, wax ... anything crafty you can get your hands on.

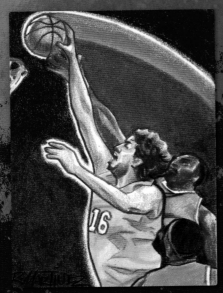
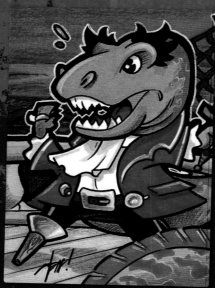
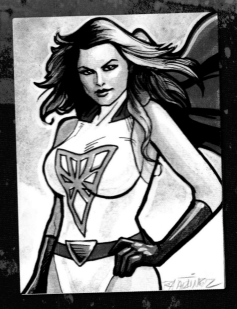
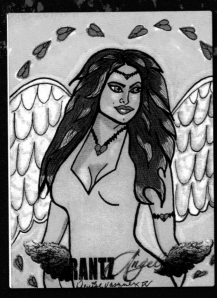
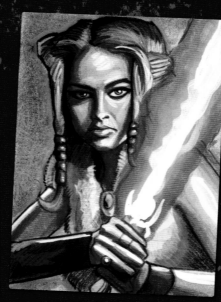
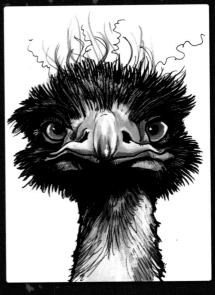
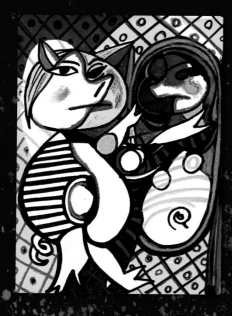
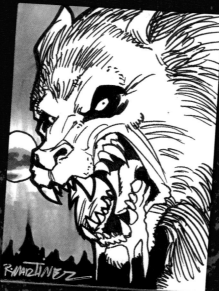
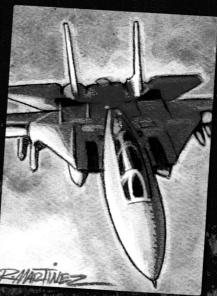

A Brief History of Sketch Cards

A sketch card is a trading card featuring original, hand-made artwork on one side. These collectible, one-of-a-kind signed pieces of art are randomly inserted by trading card manufacturers directly into trading card sets. For earlier sketch cards, professional artists used a pencil, pen or marker to create a simple piece of art. But today fans can find sketch cards created in many types of media including pencil, marker, pen, ink, water-color, gouache, gold leaf, glitter, beads, glow in the dark, metallic and many types of acrylic paint.

Over the years, sketch cards have been known by many different names, such as artist sketch cards and custom cover sketch cards (Topps), sketchagraphs (Fleer/Skybox), sketchaFEX (Rittenhouse Archives), personal sketch cards and art cards, editions and originals (ACEOs). Sketch cards commonly measure the size of a standard trading card—2½" × 3½" (6cm × 9cm)—but they can also be found in other sizes: 2½" × 4¾" (6cm × 12cm) for Topps' Widevision sizes, or 4" × 5" (10cm × 13cm) for uncut size.

As sketch card popularity grows, fans are seeking out more than just cards found in packs; they now seek out personalized sketch cards commissioned directly from their favorite artists, including up-and-comers. Walk down artists' alley at any comic book convention these days, and you will see many artists drawing on little pieces of bristol paper complete with their own logos or designs on the back.

Today, artists of all levels and professional ranks create miniature works of art on sketch cards featuring their personal logos and designs. Some cards are black-and-white sketches, some are full-color masterpieces. In the pages of *Sketch Card Mania,* we'll break down the step-by-step process of creating and personalizing your very own sketch cards and teach you how to get started selling and trading your work. Sketch cards are easy and fun, and you can make them just like the pros!

EARLY SKETCH CARDS

1993 **The Simpsons** (Art de Bart cards) Skybox

1995 **Ultra Spider-Man** Fleer

1998 **Marvel the Silver Age** Skybox

1998 **Marvel Creators Collection** Skybox

2000 **Witchblade: Millennium** Top Cow/Dynamic Forces

2001 **Women of Star Trek Voyager** Rittenhouse

2001 **Marvel Legends** Topps

2002 **Star Trek Enterprise: Season 1** Rittenhouse

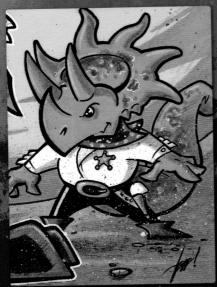

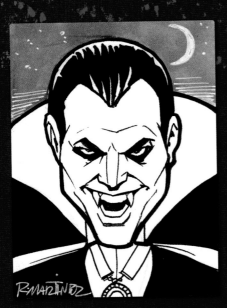

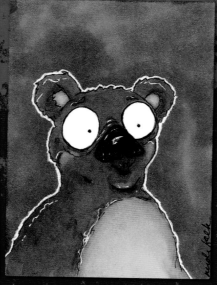

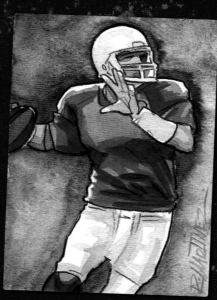

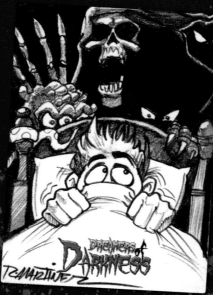

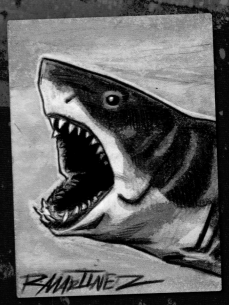

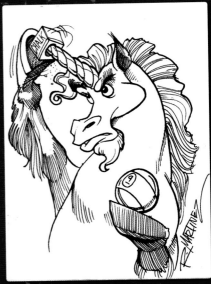

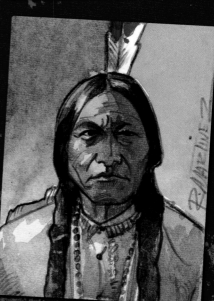

Sketch Card TOOL BOX

So you're ready to get your hands dirty and draw some really great sketch cards. But what to draw with? What to draw on? Just as there are thousands of different materials you can use to draw and paint your sketch cards, there are endless numbers of techniques you can use to create beautiful art. In this chapter we'll kick off by discussing the basics of the sketch card industry's most commonly used media and techniques. These techniques will give you a solid foundation for drawing and painting awesome sketch cards of your very own.

Basic Shapes

When thinking about what to draw on your sketch cards, it helps to see the world in very basic terms. Looking at objects as basic shapes will help you realize how simple they are to draw. Start by seeing everything as shapes—first large shapes, then smaller shapes inside those larger shapes.

Simple Shapes

A basketball is just a simple circle. A shark's tooth is a triangle. A TV is a square. Look for other things around you that can be broken down into basic shapes.

 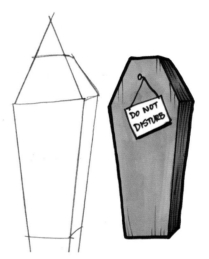

Three-Dimensional Shapes

Start looking for shapes that are three-dimensional. A soda can is a cylinder. A briefcase is a box. A coffin is almost a hexagon box.

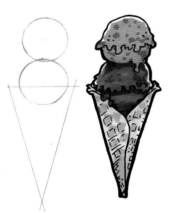

Multiple Shapes

See if you can find multiple shapes within an object—an ice cream cone, an alien or a bass guitar. There are lots of small shapes within these objects. And that's the basic secret of drawing. See how simple it is?

Color

Understanding the basic terms and concepts of color will help keep your cards looking professional. After you've got your card sketched out and are ready to add a color medium, decide on your color scheme. A color scheme is a selected set of colors that work well together. For sketch cards, this usually means two to three colors, or one color with a variety of shades.

Contrasting Colors

When choosing a color scheme, the easiest place to start is contrasting colors. On the color wheel are the primary colors (red, yellow and blue) and the secondary colors (orange, green and violet). Each color's complement sits on the opposite side of the color wheel—red is across from green, blue is across from orange and yellow is across from violet. These are called complementary colors and are an easy indicator of contrasting colors.

The farther away your colors are on the color wheel (two complementary colors), the more stark the contrast. The closer they are on the wheel (blue and purple, for instance), the more subtle the contrast.

Look for Color Schemes in Real Life

Look around you for great color schemes—your favorite sports teams, cereal boxes, bags of chips, soft drink cans, magazine advertisements and DVD covers. All of these are ready-made examples of color schemes that could work for you when selecting colors for your sketch cards.

▶ **Basic Color Wheel**
Use a color wheel to understand the basic relationships between colors. By mixing complementary colors—those directly across from each other on the wheel—you can achieve a nice variety of gray tones.

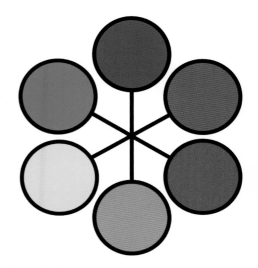

cool color scheme

warm color scheme

cool and warm color scheme

Warm and Cool Color Schemes
An easy way to create contrast is to use warm and cool colors against one another. Warm colors are red, orange and yellow, while cool colors are blue, purple and green. Warm and cool colors always create good contrast.

Graphite Pencils

The most basic and popular drawing medium for sketch cards is the good old classic graphite pencil. No matter how you end up finishing your art, it usually starts with a pencil sketch.

Pencil Grades

There are many different grades of pencils available that are distinguished by their markings. H stands for hardness, B stands for blackness, and the number tells you how soft the lead is. H pencils are harder and leave a lighter mark. B pencils are made of soft graphite and are good for sketching because they create nice, dark lines. Be careful, though; too soft of lead can be difficult to erase without smudging the paper.

For beginners, it's best to start somewhere in the middle with an HB pencil, or what you might know as the standard school-issued no. 2 pencil. Once you get a handle with the HB, you can go to a higher B or H depending on your drawing skills. The most important thing is to find a pencil that you feel comfortable using.

Erasers

There are a number of different types of erasers, but when starting off we recommend a simple gray kneaded eraser. They are soft and easy on the drawing surface, and can pick up just about any line. You can rub out a big area or shape the eraser into a point to get at small areas. Gray kneaded erasers don't break apart like most other erasers, so they leave little mess. The best part about kneaded erasers is they stretch and bend so you can sculpt things out of them when you are bored.

▶ **Basic Drawing Tools**
Keep a variety of graphite pencils and erasers handy to achieve the desired effect for different jobs. Also invest in a good pencil sharpener to keep your pencil points sharp.

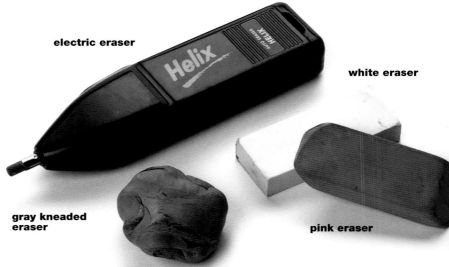

electric eraser

white eraser

gray kneaded eraser

pink eraser

Paper

Your paper choice is the most important decision in creating sketch cards. Use a thick stock of paper with a good drawing surface. Choosing the correct paper for the media you will be using will be the difference between a mess and a masterpiece.

More expensive does not always mean better. Student-grade paper is often sufficient. Be sure the paper you choose is acid free. This means all acids used in the process of making the paper have been removed. This will keep your sketch cards from turning yellow over time.

Bristol Paper

Bristol is the most ideal paper for creating sketch cards. It's thick enough to hold just about every medium discussed in this book and has a great tooth for drawing with pencils, pens and markers. It comes in two kinds of finishes: smooth (hot press) and vellum (cold press). Cold-pressed paper has more tooth and works well with paint and pastel.

Watercolor Paper

This paper is made specifically for watercolor. The fibers absorb the watercolor so the paper doesn't buckle or warp. Watercolor paper is good to draw on, too. It has a great tooth and cool texture.

Decorative Paper

Decorative paper is fun to use as a drawing surface as long as it is thick like cardstock. Check the type of finish first. If it's too glossy, it will limit the type of material you can use to draw with.

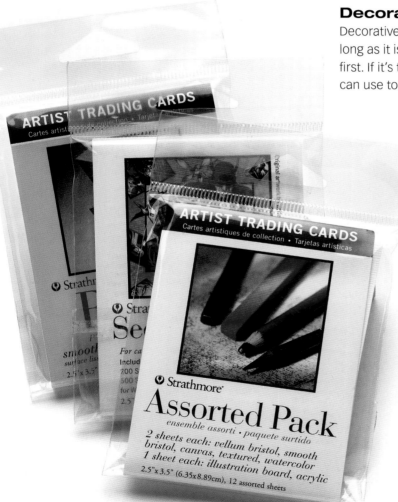

Experiment on a Variety of Papers

These variety packs of paper are pre-cut in standard sketch card size (2½" × 3½" [6cm × 9cm]). They contain two sheets each of vellum bristol, smooth bristol, canvas paper, textured paper and watercolor paper, and one sheet each of illustration board and acrylic paper. Pre-cut cards are not ideal for affixing your sketch card backs, but they are great for experimenting with different paper types without spending a ton of money on each type.

Graphite Pencil

Graphite is a great tool to draw with because you can draw with a full range of lights and darks. The more you draw with graphite, the better your control will be of the medium. Practice making light to dark gray scales with a graphite pencil. How light or firm you apply the pencil is everything when drawing with graphite. This warrior princess sketch card was created using a simple no. 2 pencil.

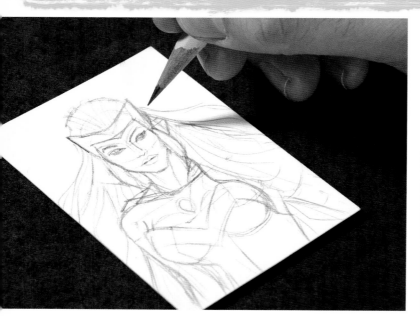

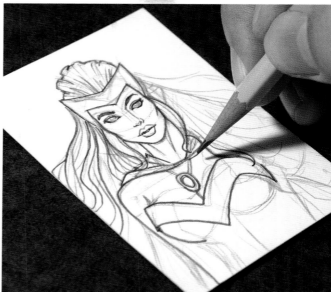

1 Before you apply any marks to your sketch card, create a few practice drawings on other paper. When you've decided on your subject, begin drawing in the basic lines and features you want to keep from your practice drawing.

When drawing in graphite, always start out drawing lightly. You can erase your foundation lines later, or you can keep them and use them as part of your shading. Notice that my lines are light and fairly sketchy. It is at this point that you would decide what medium you are going to use to complete your sketch card.

2 Continue to build your subject from shapes and guidelines. Draw only the lines you want to keep, excluding guidelines and unwanted lines. In the early stages, your sketch card should be just that: sketchy.

SKETCH LIGHTLY

Do not sketch with heavy dark lines. Sketch with light, easy-to-read and easy-to-erase lines. When you're ready to add the final lines and details, switch to a darker pencil. Use your darkest pencil (or a black pen or marker) to create any shading and texture at the very end.

too dark **just right**

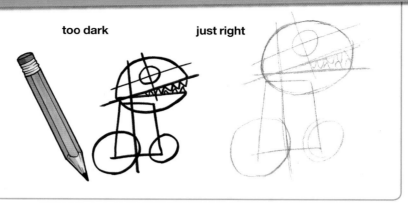

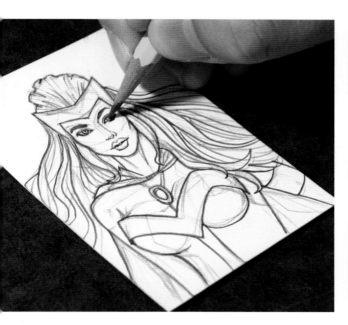

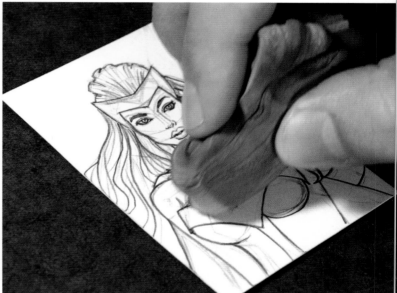

3 Continue outlining the lines you want to keep. Keep your pencil sharpened for small details like the eyes and mouth. Do not shade in anything at this point, just go for the lines.

4 Lightly rub a kneaded eraser over the entire card. The light sketch lines will disappear, leaving only the dark lines you outlined earlier.

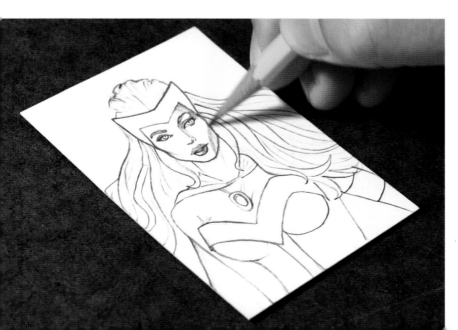

5 Once you have erased all of your unwanted sketch lines, lightly draw in the shadows. Start by using very light strokes of your pencil. You will notice that the more you sketch over one area, the darker it gets without pushing hard on the pencil. Don't cover any area too solidly; leave some white for highlights.

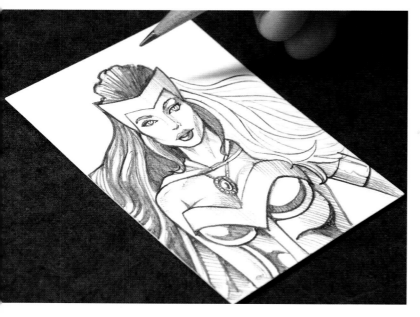

6 After you have drawn in your light shadows, begin shading in the dark areas and lines. Vary the darkness of your lines and shadows. The darkest darks should be reserved for areas that receive the least light and details like eyelashes.

7 Finish up your drawing by adding smaller details. You don't need to draw every strand of hair. Simply suggest hair by using a few lines of varied thickness.

8 Add your signature, then sit back and admire your cool graphite sketch card!

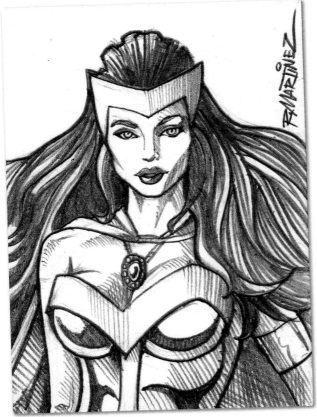

WARRIOR PRINCESS
Sketch card by Randy Martinez

PRACTICE BLENDING WITH A SMUDGE STICK

Smudge sticks, or tortillions, are sticks of tightly rolled paper used to blend and smudge graphite. Hold at an angle to avoid piercing the paper.

GRAPHITE Sketch Cards

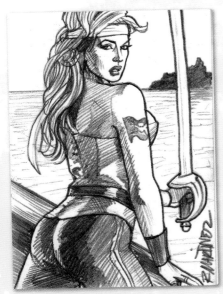

PIRATE GIRL
Sketch card by Randy Martinez

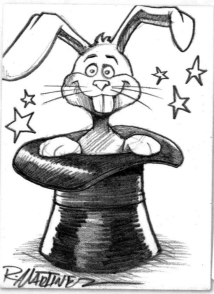

MAGIC
Sketch card by Randy Martinez

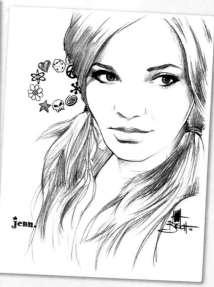

JENN
Sketch card by Matt Busch

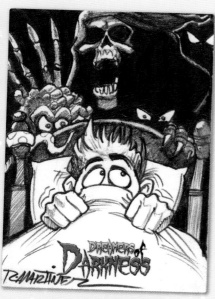

BAD DREAMS
Sketch card by Randy Martinez

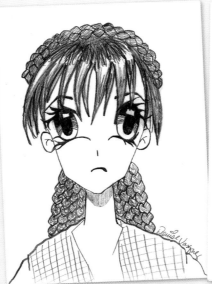

MANGA GIRL
Sketch card by Denise Vasquez

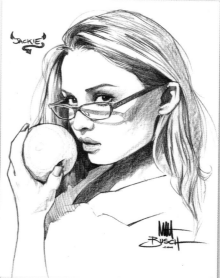

JACKIE
Sketch card by Matt Busch

Colored Pencil

Colored pencils are one of the most popular drawing tools in all of illustration. They are versatile, vibrant and easy to use without needing water or solvent.

There are several good colored pencil manufacturers out there, and their pencils all have different hardness. I prefer a medium pencil lead. Try them out and see what you like best. Color-wise you can't go wrong buying a starter set of basic colors. Colored pencils are generally inexpensive, so as you improve pick up different colors to add to your color collection.

Wax-Based Colored Pencils

Wax-based colored pencils are the most commonly used. They create solid, permanent marks and blend nicely. Wax-based pencils layer easily to create new blended colors.

Watercolor Pencils

Watercolor pencils are a cool art material. They work just like regular colored pencils, but are water soluble. When you take a wet brush to the color marks, they dissolve and you can create brushstrokes just like with watercolor.

MIX YOUR MEDIUMS

Since colored pencil is a dry medium, it works great with other types of mediums. Try colored pencils on top of your pen, marker and graphite sketches to create cool mixed-media effects.

Color Fast and Easy With Colored Pencils

Different types and brands of colored pencils have different softness, quality and finish. Try them all, mix and match, and see what happens.

Colored Pencil

Colored pencils are one of the easiest color mediums to use on your sketch cards. If you can draw with a pencil, you can color with colored pencils. This exercise shows you the basics of colored pencil shading and layering.

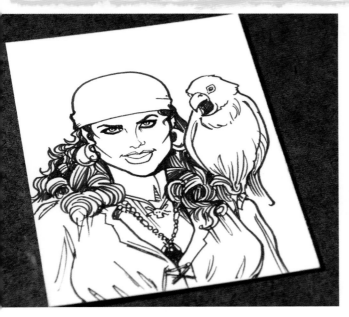

1 Sketch your initial lines in graphite or pen. Be sure to erase all unwanted sketch lines before adding color.

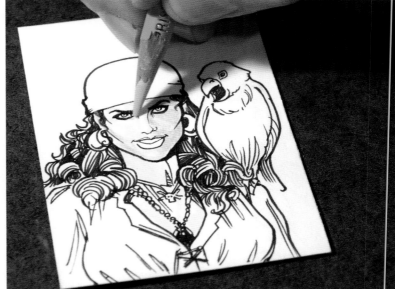

2 With a light touch, draw in your lightest tones with Light Peach. Use a circular motion when applying the colored pencil. This will give a nice even application of color. Do not cover the entire area. Leave some white showing for highlights.

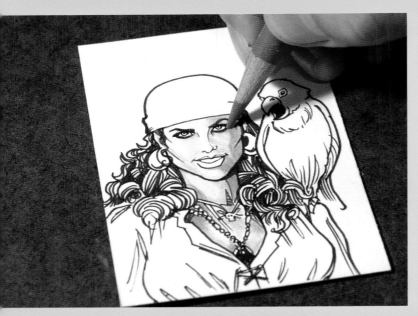

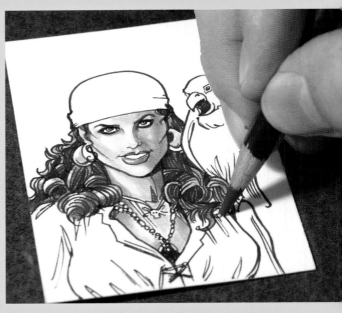

3 Add a darker shade of orange for shadows on the face. Continue to lightly lay in color in a circular motion. Just like with graphite, the more you draw in one area, the richer the color becomes. You want some of the color from your first layer to show through, so take your time and build up the color where it's needed.

4 Continue laying in color. Be sure to leave highlights, and use a variety of different shades and tones to achieve the illusion of form.

7 Fill in the parrot with a bright green. To give his feathers a little texture, roughly scrub in the pencil rather than use an even, circular motion.

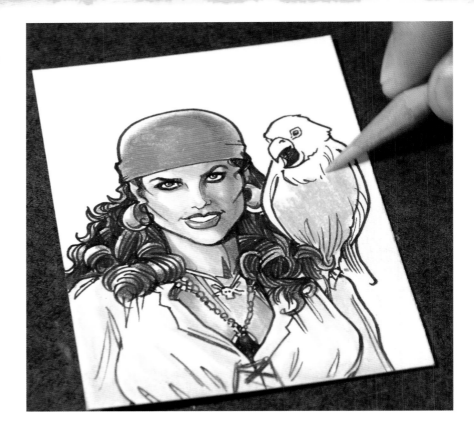

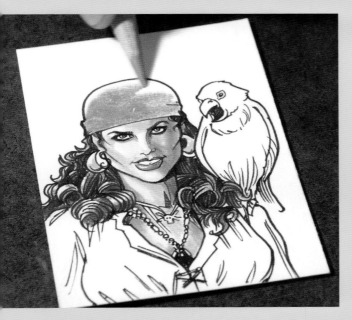

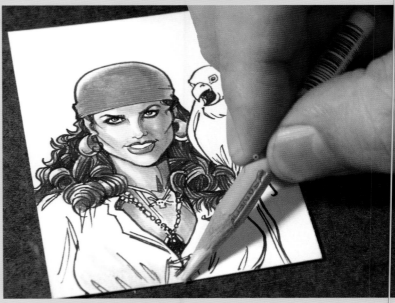

5 Draw lighter to establish highlights, and harder where you want richer color. This technique is helpful to achieve form without making your art darker.

6 Pay attention to the lighting source on your subject and the direction of the shadows. Add more color in the shirt and create matching cast shadows and highlights.

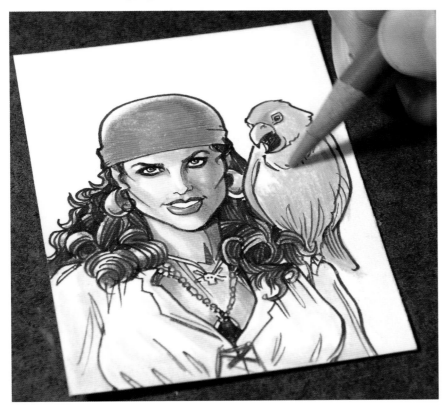

8 Using the same scrubbing motion, lightly lay down a darker green for shadows on the parrot. Once the basic colors are established, begin adding details. It's always best to do details at the end.

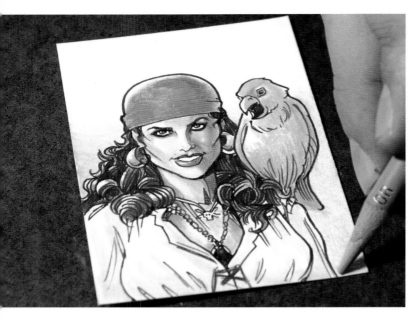

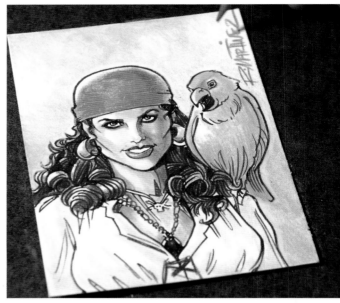

9 Color in a blue sky with some wispy clouds. Using a circular motion, add in an even layer of color. Control the cloud placement by adjusting the pressure you put on the pencil and by how much color you add over the same area.

10 Sign your card where the colored pencil laid down is light. It's tough to draw crisp lines over built-up colored pencils, so make sure the pencil is sharp. Choose a nice color for your signature that complements the colors in the card. Here I chose the color I used for the bandana.

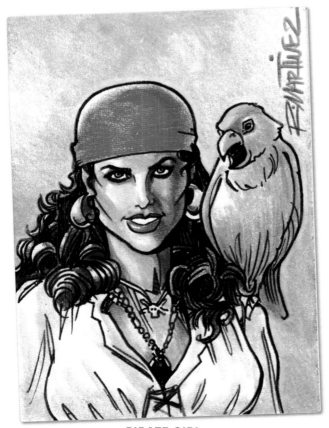

PIRATE GIRL
Sketch card by Randy Martinez

WATCH OUT FOR WAX BLOOM

Wax bloom is the cloudy color that occurs when the wax of the pencil rises to the top of the drawing surface. This happens most often when the pencil is applied heavily. To prevent, spray your sketch card with a fixative. This clears up the wax bloom and brings out the brilliant color of the pencils.

COLORED PENCIL Sketch Cards

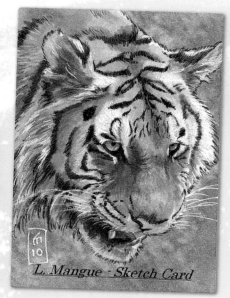

TIGER
Sketch card by Leah Mangue

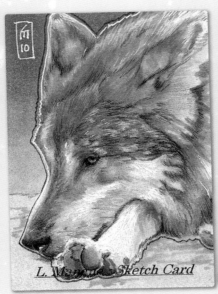

WOLF
Sketch card by Leah Mangue

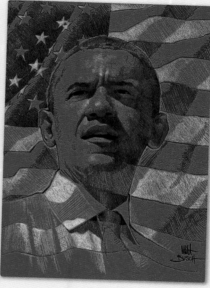

OBAMA
Sketch card by Matt Busch

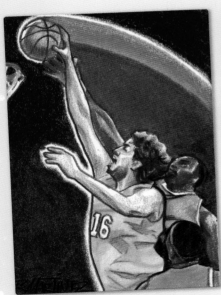

BASKETBALL PLAYER
Sketch card by Randy Martinez

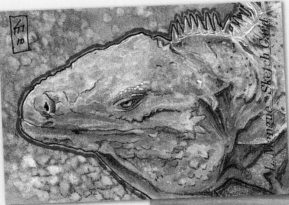

IGUANA
Sketch card by Leah Mangue

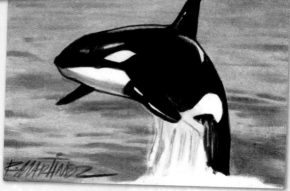

ORCA WHALE
Sketch card by Randy Martinez

Pens and Markers

There are literally hundreds of different brands and types of drawing pens. For sketch cards, we recommend that you use waterproof or permanent pens.

With all the great products out there, choosing good pens may seem overwhelming. The important thing is that you get the pen that works best with other materials, but also what feels good to you. Visit your local art store and test different pens out and find the ones that suit you best.

Permanent Pens

Permanent is good choice for sketch cards if you want to add color or other mediums to the sketch cards because the ink won't lift or bleed. Most permanent pens are made with smelly solvents and can sometimes give you a nasty headache if you are exposed to them too long. If this becomes a problem, odorless permanent pens are available, but that might mean the pigment isn't as rich.

Water-Based Pens

Water-based pens are OK to use for your sketch cards as long as you are not going to do anything else to the artwork. The water-based ink will bleed and lift if other semi-wet materials are applied on or next to it.

VARY YOUR LINES WITH DIFFERENT PEN TIP SIZES

Pens come in many different sizes, some as thin as a fingernail. A fine tip drawing pen is great for small details.

Permanent and Waterproof Pens
Look for pens with a rich, black pigment, strong and flexible nib, and matte finish. Make sure your pens hold plenty of ink. It's terrible to run out of ink in the middle of a drawing.

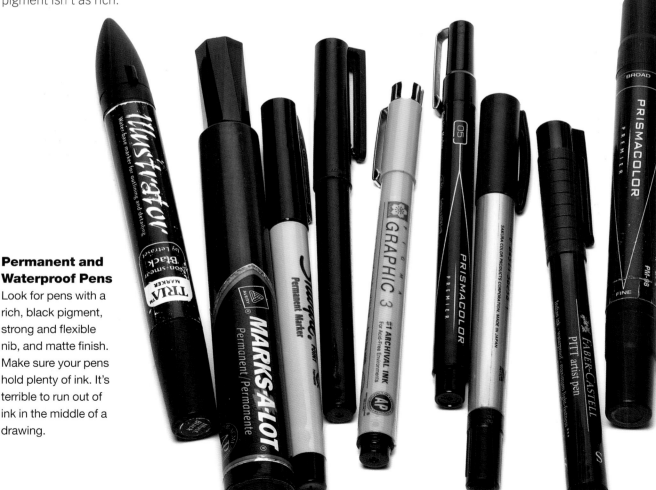

Colored Markers

Markers are another great way to add color to your sketch cards. They are easy to use, dry quickly and work well on a variety of surfaces. Solvent-based markers are permanent and are not as vulnerable to fading as water-based markers.

Marker Colors

You don't need to buy the most expensive marker brands out there, but do strive for a wide selection of colors and shades. Try to have three or four different shades of each of the primary and secondary colors. Gray markers are great for tinting colors or shading whites. Keep a full range of light to dark grays on hand. A variety of browns, peaches and pinks is useful for drawing people.

Paper

When using colored markers it is important to use the right kind of paper. Use paper that will easily absorb the marker color but not bleed. Bristol or cotton-bond cover stock work well.

APPLY YOUR BLACK LINES AFTER ADDING COLOR

The solvent in colored markers might lift the black ink and smear the color. To avoid this, add color before you ink your black lines.

Colored Markers

Markers are a quick, convenient way to color. They dry fast and are easy to blend. If you run out of a marker, buy the same type and pigment and seamlessly continue your work.

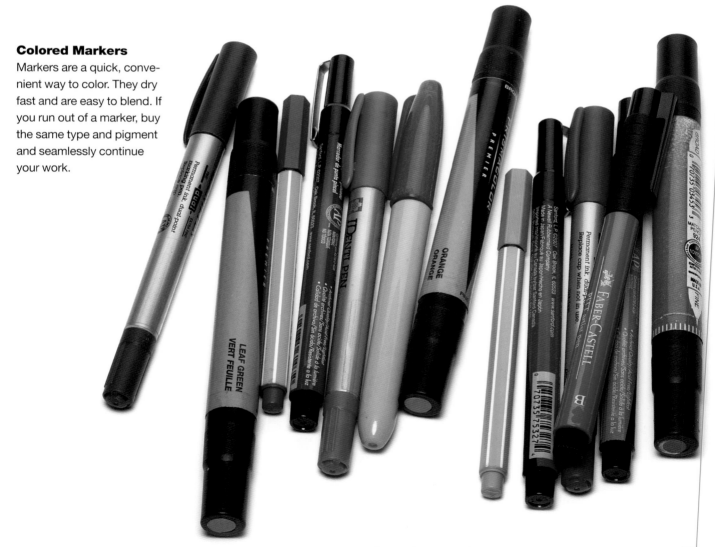

Colored Marker

Colored markers are a popular medium for creating sketch cards because they are brilliant in color, dry instantly, have great blending capabilities and work well with other mediums. Use a variety of solvent-based markers for this technique exercise. They are permanent and cannot be lifted by water. Let's run through the basics of working with colored markers.

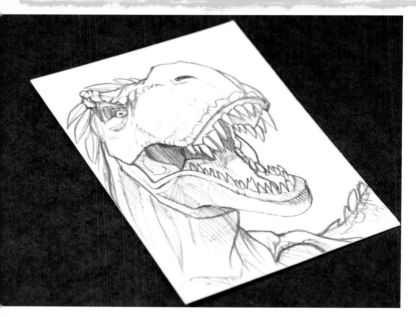

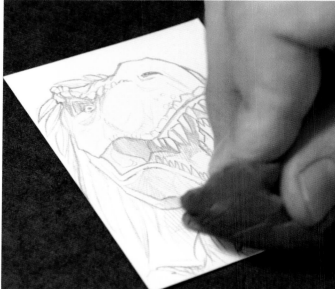

1 Lightly sketch your drawing on the sketch card with a no. 2 pencil. With harder pressure, draw over the lines you wish to keep.

2 Lightly erase the foundation and guidelines you don't want in the drawing. Flatten your kneaded eraser and press it against the darker lines all over the drawing to lighten the lines and remove loose graphite. This will keep the graphite from dirtying your marker tip or smearing into your drawing.

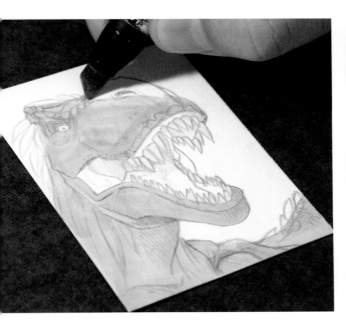

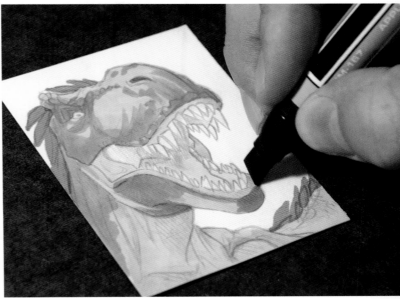

3 Fill in the lightest shades of color on your card starting with light green. Add light pink in the mouth and a cream color to the teeth. Use only light tones in this early coloring step.

4 Add the middle tones, a darker green and darker pink, leaving some of the lighter tones from the previous step for highlights. Don't add any more color to the highlight areas.

5 Add darker shadows in the mouth with dark red. The shadows add strong contrast to the teeth so that they really pop. Continue adding middle tones to the body and head with darker greens.

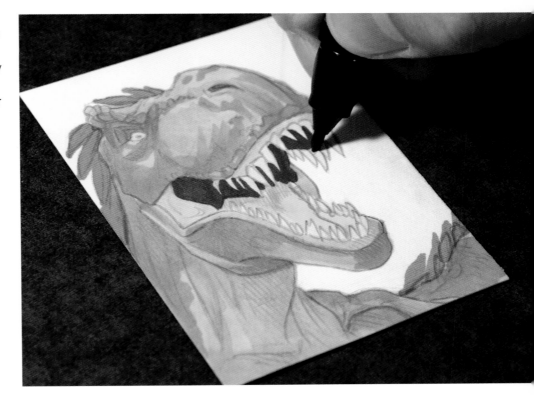

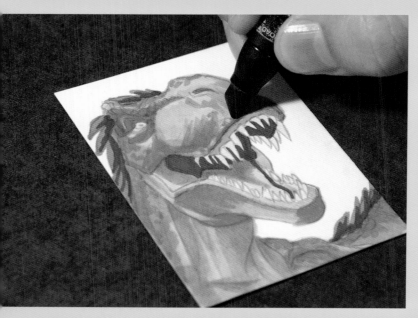

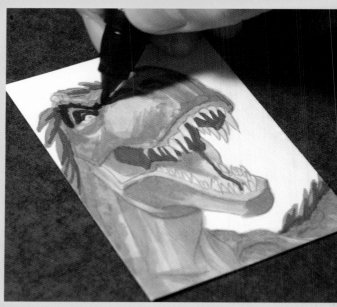

6 Continue filling in the darker shadows. Don't go crazy with the shadows—a little can go a long way. Be sure to let some of the lighter tones shine through. While you are at it, draw in some brighter middle tones like I have done with the green spots on the dinosaur's back.

7 Use a black pen or a dark pencil to color in the darkest darks in your drawing. Darken the small details such as the eyes, nostril, neckline and mouth.

10 With a fine tip pen, outline your subject. Use a variation of thick and thin lines, but do not use so much of the black lines that you take away from the nice coloring job you have done.

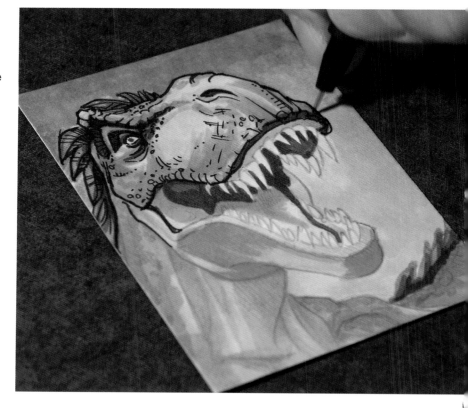

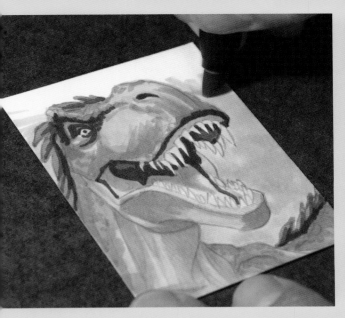

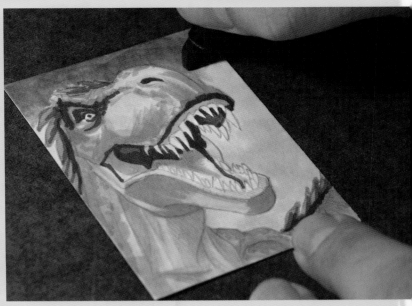

8 Use a light blue color to fill in two-thirds of the background space.

9 Fill in the top third of the background with a middle blue tone. Scrub the light blue color into the middle blue tone to blend the two colors together. With practice you can achieve really nice gradients by blending colored markers into each other.

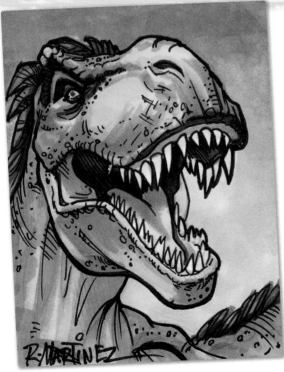

T-REX
Sketch card by Randy Martinez

11 Your final drawing should be an even mix of tones, shadows and lines. Notice that the thicker lines on the underside of the dinosaur help create the illusion of weight and form. Don't forget to sign your sketch card!

PEN AND INK
Sketch Cards

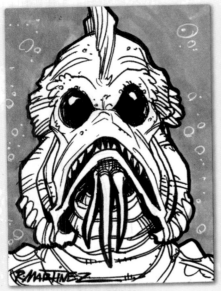

GILL MAN
Sketch card by Randy Martinez

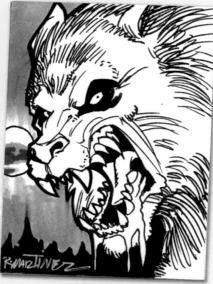

WEREWOLF
Sketch card by Randy Martinez

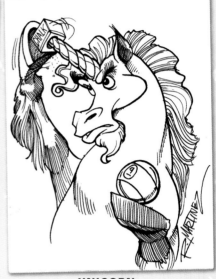

UNICORN
Sketch card by Randy Martinez

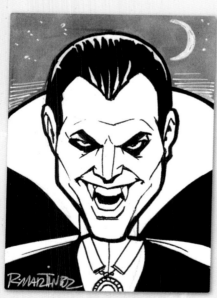

DRACULA
Sketch card by Randy Martinez

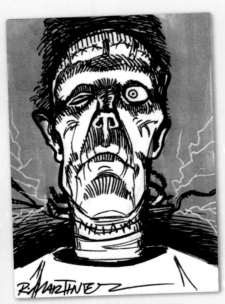

FRANKENSTEIN'S MONSTER
Sketch card by Randy Martinez

COLORED MARKER Sketch Cards

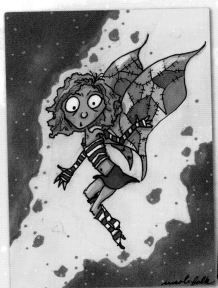

STITCHED FAIRY
Sketch card by Nicole Falk

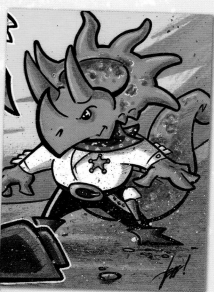

OLD WEST DINOSAUR
Sketch card by Jeff Chandler

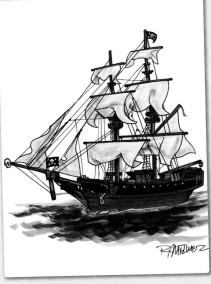

PIRATE SHIP
Sketch card by Randy Martinez

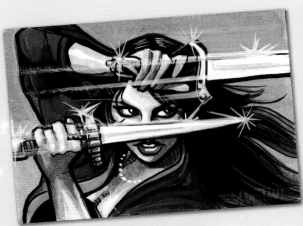

GYPSY WARRIOR
Sketch card by Randy Martinez

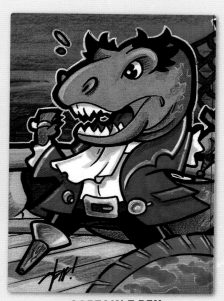

CAPTAIN T-REX
Sketch card by Jeff Chandler

Brushes

Brushes are used for different types of mediums and come in many shapes and sizes, each made for a specific purpose. Some brushes are used to create washes, a thin application of paint over a large area, while some are for detail and others are for texturing.

Brush Size and Type

For sketch cards, you'll need both round and flat brushes in a variety of sizes. The more sizes and shapes you have, the better control you will have over the paint when applying it. Small, fine tipped rounds are great for detailed areas. Larger rounds are good for laying in expressive thick and thin brushstrokes. Flats are good for large areas of paint such as watercolor washes, while angled flats work well in corners.

Brushes vary greatly in quality as well as hair type—either real or synthetic. Pure sable brushes are expensive but will last you for years. On the other end, many types of synthetic brushes cost very little but do not last that long. You get what you pay for with brushes. The trick is to find what works for your budget and artistic needs. Just be sure to buy brushes that won't frustrate you by falling apart in the middle of a painting.

Caring for Your Brushes

Rinse out your brushes every time you change your painting water. It is OK to let them soak in the water while you work, but do not leave them for too long. Take care of your brushes and they will take care of you!

Palette

Palettes come in many shapes and sizes. A round palette works well for sketch cards. Divots for each color keep them separate, and the middle can be used to mix colors and create color washes with water.

▼ **Tools for Painting**
From left, water jar to wash your brushes; palette with mixing areas and separations for paint colors; assortment of round, flat and angled flat brushes; and paper towels.

Acrylic

Acrylic paint is one of the most versatile paints to work with. You can apply it thick like oil paint or thin like watercolor. Acrylic paint is water-based and includes a synthetic binder that makes it both waterproof and fast drying. Acrylics are great for layering color because they don't lift the base or middle tones.

When dry, acrylics won't smudge, lift or peel off. That means other water mediums cannot be laid on top. However, you can work into acrylic with ink, colored pencils, graphite and markers. When mixing mediums with acrylic, keep in mind that the thicker you apply the paint, the slicker the surface will be so other mediums will not stick to it well.

Experiment with these different types of acrylic paints:

▶ **Heavy body acrylics** are the most common type. They are extra thick, about the consistency of toothpaste.
▶ **Concentrated acrylics** are a little more fluid than heavy body acrylics and of medium viscosity.
▶ **Fluid acrylics** have a low viscosity and are about the consistency of dishwashing soap.
▶ **Acrylic gouache** is opaque and dries to a matte finish. Unlike watercolor gouache, it contains a binder that makes it waterproof when dry.

▼ Experiment With Different Types of Acrylic
Acrylic paints come in a wide range of thicknesses, many of which work great for sketch cards. Experiment with different types to see how you like the fluidity, drying time and richness of color.

ACRYLIC PALETTE

You can mix a wide variety of colors using this limited palette: Cadmium Red Light, Alizarin Crimson, Cadmium Yellow, Ultramarine Blue, Cerulean Blue and Titanium White. Because acrylic pigments do not mix the same as watercolor, it helps to have a few more colors in your palette to ensure bright, rich tones: Bright Green, Burnt Umber, Ochre, Black, Teal and Bright Orange.

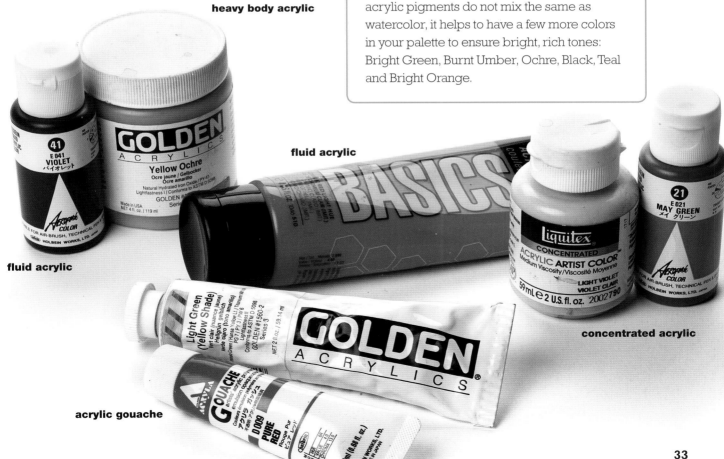

heavy body acrylic

fluid acrylic

fluid acrylic

concentrated acrylic

acrylic gouache

Watercolor

Watercolor is a diverse medium. It dries quickly and you can get a full range of brilliant colors by simply varying the amount of water you add to the pigment. Watercolor can be applied thinly in transparent layers to build color. After it dries, it can be made fluid again by reapplying water.

There is a whole range of quality in watercolor paints. It's best to buy watercolors from a reputable brand. You can mix just about any color possible with only these few colors on your palette: Cadmium Red Light, Alizarin Crimson, Cadmium Yellow, Ultramarine Blue and Cerulean Blue. The lightness of watercolor paint will depend on the amount of water you add, so you don't need white paint.

Gouache

Try gouache if you are in need of a less transparent color. Gouache is opaque watercolor, which means it dries flat and is not translucent. Adding water to gouache will thin it out and achieve some nice smoke or haze effects.

Paper

Watercolor is very wet and requires a durable paper that won't curl or buckle when water is added. With sketch cards, experiment with different weights and textured surfaces to find one that works best.

Watercolor Tubes Provide Rich Tones
Watercolor paint is sold in tubes, cakes or watercolor trays. Tubes offer the richest color, but high-end cakes or trays work well, too. Watercolor trays are ideal for portability.

WATERCOLOR PALETTE

You can mix a wide variety of colors using this limited watercolor palette: Cadmium Red Light, Alizarin Crimson, Cadmium Yellow, Ultramarine Blue and Cerulean Blue.

Watercolor

You can try many techniques with watercolor, but it can be frustrating if you don't understand the basics of the medium. You must remember that no matter how dry the paint is, adding water again will always lift the color. In this lesson, we'll review the basics of watercolor—how to apply a wash and how to paint wet-into-wet. Use a small round brush specifically for watercolor. Its long bristles are designed to hold more paint.

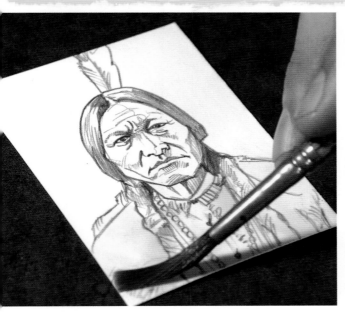

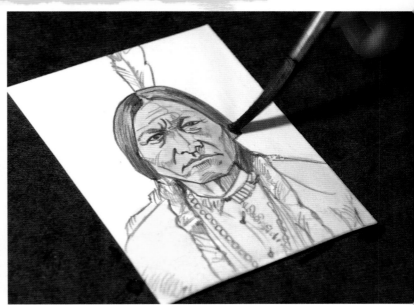

1 Finalize your pencil sketch before turning to watercolor. Start by painting a wash of the lightest base tone, in this case Yellow Ochre. Remember the more water you use, the lighter the color will be. Paint everything except the highlights, which should be left the white of the paper. Let the paint dry completely.

2 Add the middle tones—a red-brown mixture—over the initial wash. You don't want the water to puddle, so lay in the paint with quick strokes. Let it dry.

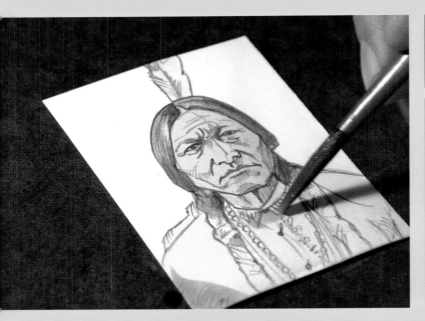

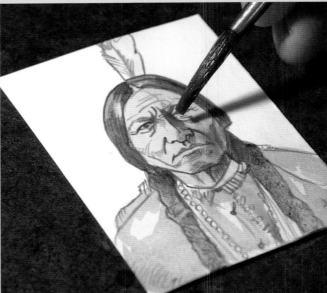

3 Lay in more of the initial wash tone from step 1 where you want the color to be the richest. Use quick strokes to avoid puddling. Let it dry.

4 Continue adding rich middle colors making sure to leave the highlights. Darken the middle tones by mixing in a little Ultramarine Blue or Alizarin Crimson. Experiment on a separate piece of paper.

7 Paint in the background color. You can either build it up like you have done with the foreground or paint in a nice bright layer.

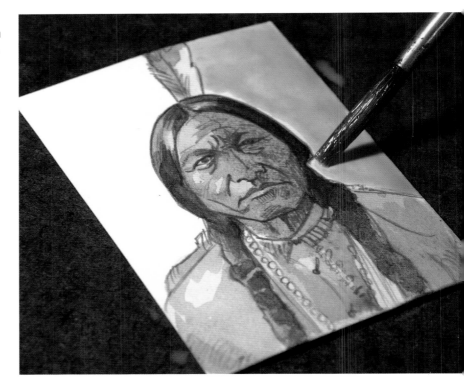

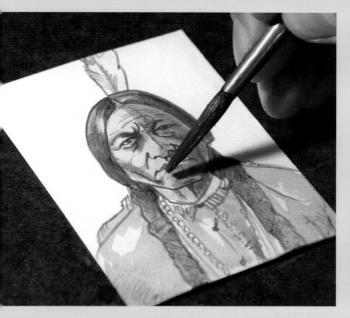

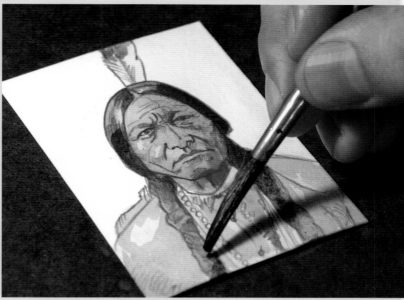

5 In watercolor, it's important to always paint in your darks last. For your darkest colors mix your own black. Use a combination of dark blue, dark red and a spot of yellow to mix a rich violet. While it looks black, it's really a natural dark that won't overpower or muddy your art like black from a tube might.

6 Continue to paint in the darkest darks. Make your wash slightly darker than the brightest wash. Do not try to create dark tones with black. It will only make your colors muddy and gray. Use a smaller brush to get some of the smaller details.

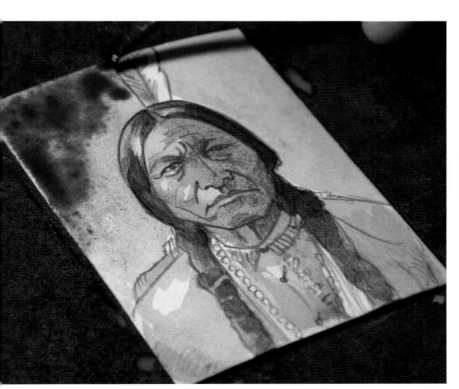

8 Continue painting the background wet-into-wet. Paint the right side with Bright Green to contrast the earthy tones. Paint a light wash of violet and then add in a second, richer layer of violet before the first wash dries. This creates a nice bleed effect.

AVOID BLACK AND WHITE

To keep your watercolors clean and bright, never use black and never use white. Black muddies your colors and white makes them opaque. The white of your paper will be enough to keep your colors bright.

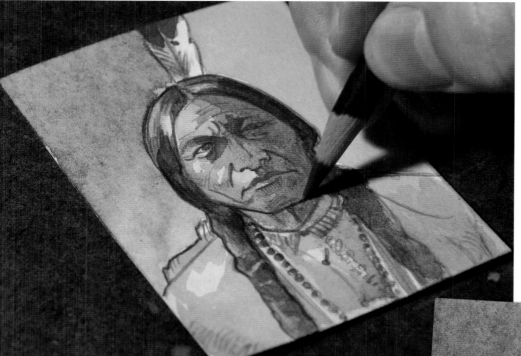

9 After your piece has dried, go back and beef up the pencil drawing. You can even draw in some white highlights or detail colors with colored pencils.

10 Sign your watercolor sketch card with a pencil or pen.

EXPERIMENT FOR COOL WATERCOLOR EFFECTS

Experiment by adding paint to your surface at different stages of drying to create cool effects.

- Add paint to wet surfaces to cause paint to bleed and spread wherever there's water.
- Create a net-like pattern through a bit of water reticulation by puddling watercolor washes.
- Lay down a wash over thicker dried paint.

NATIVE AMERICAN
Sketch card by Randy Martinez

WATERCOLOR Sketch Cards

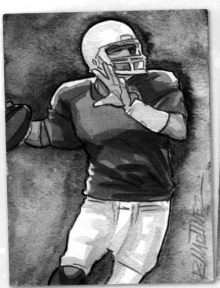

FOOTBALL PLAYER
Sketch card by Randy Martinez

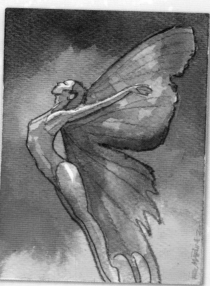

FAIRY
Sketch card by Randy Martinez

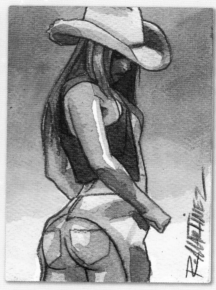

COWGIRL
Sketch card by Randy Martinez

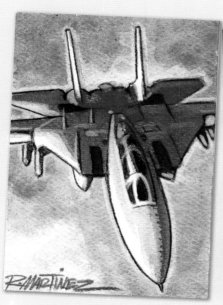

F-14 JET
Sketch card by Randy Martinez

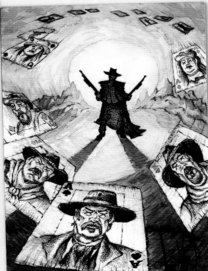

DECK OF THE DEAD
Sketch card by Alex Alderete

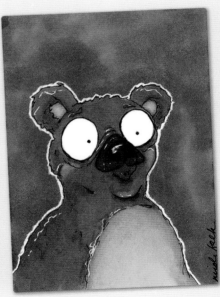

BEAR
Sketch card by Nicole Falk

TECHNIQUE
Acrylic

In acrylic, you can achieve many different effects and mimic other materials. You can paint acrylic thin like watercolor, opaque like gouache, or thick and textured like oil paint. The most common way to apply acrylic paint is to start with thin washes and finish with thick paint application. This is also the way oil paint is applied, but because oil paint is a big no-no with sketch cards, acrylic is the perfect substitute.

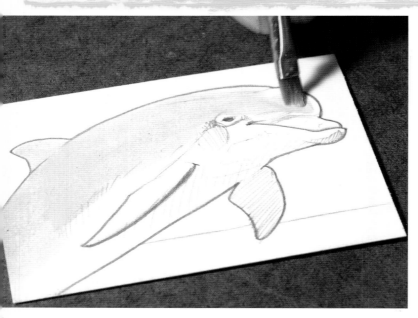

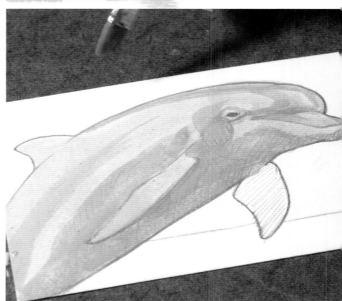

1 Start by painting in your light gray with a small flat brush. Some people prefer to paint the darkest dark first, but in this exercise we will build up the darks slowly on top of the pencil sketch.

2 While the first layer of paint is still wet, lay in your shadows (not yet your darkest darks). Always clean your brush between colors. Blending will occur naturally working wet-into-wet. Pull the darker color away from the lighter color to keep the transition smooth. Let it dry.

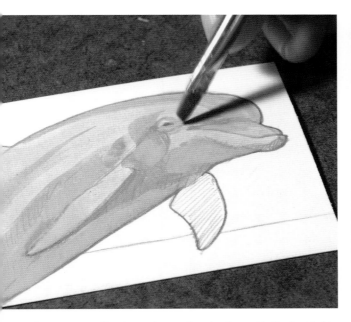

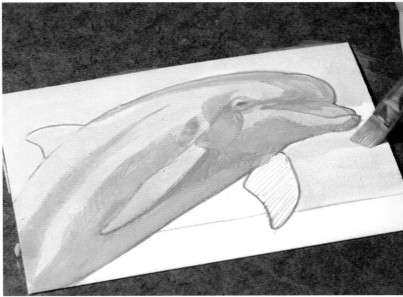

3 Paint in reflective color on the shadows. Reflected light is the light that reflects off an unseen plane underneath the form you are painting. In this case, a shade of blue slightly lighter than the shadow area. Don't cover all of the shadow; a few strokes will help create form.

4 After the dolphin is colored in, fill in the background with a light blue. This will help you judge how light or dark the background should be to contrast the dolphin. The light blue contrasts the shadows on the dolphin and picks up a hint of the reflective light on the dolphin's belly.

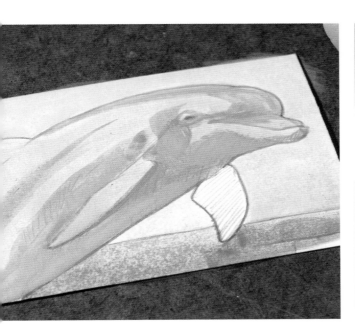

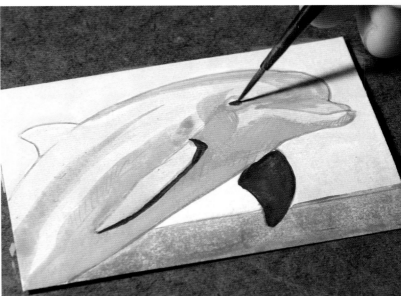

5 Continue painting the water portion of the background a rich blue. Now you can really see the relationship of the water and reflective light on the dolphin's belly.

6 Paint in the darkest colors with a small round brush, in this case a very dark gray. Be sparing with how much you use. A few hints of darks go a long way.

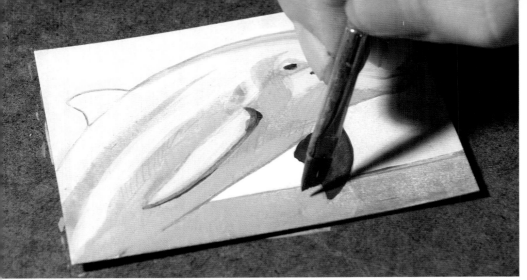

7 Using a small flat brush, paint a bright blue on top of the middle tone of the water in the background. Let some of the original blue show through.

8 Go back to the dolphin and paint in details and clean up the edges. Add a few touches of brighter reflective blue on the dolphin's head and back.

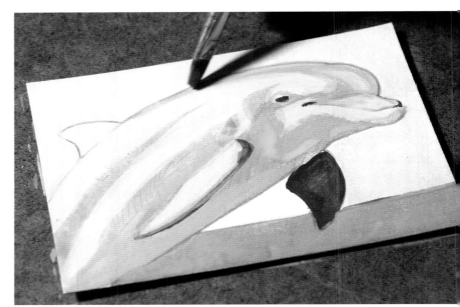

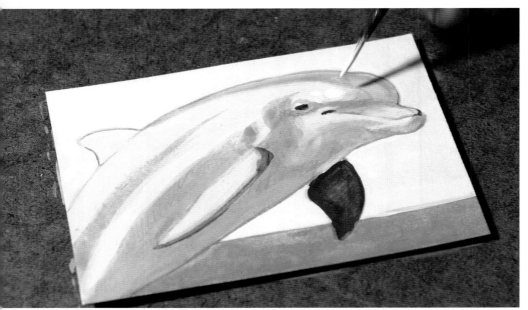

9 Paint in the brightest brights with white paint for the white highlights. These are sometimes called hot spots. Be careful. With dark tones, a few highlights go a long way. So use a small round brush for the details and be sparing with how much white you use.

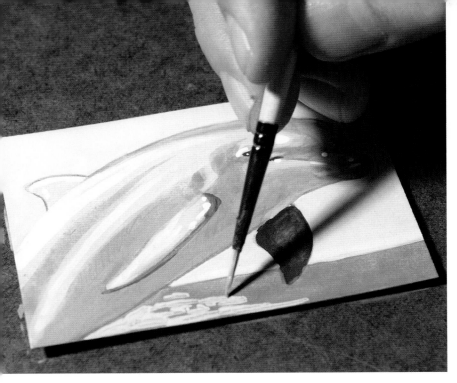

10 Finish up your background by painting random highlights of light blue. Be sure to let some of the richer blue show through to maintain the illusion of water.

11 Using white paint or a very light blue, add a few final details such as water falling off the dolphin's flippers. Paint in one direction to give the dolphin the illusion of movement.

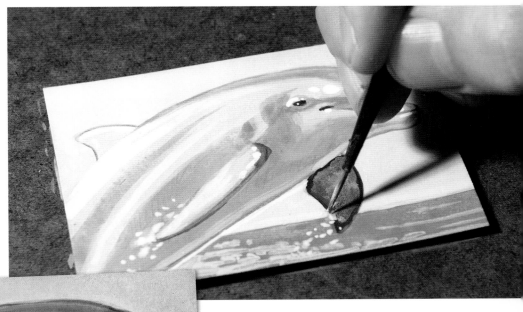

12 Sign your new piece! Acrylics are tricky at first and will take some time to get used to, but with practice and experimentation, you'll be a pro in no time at all.

DOLPHIN
Sketch card by Randy Martinez

ACRYLIC Sketch Cards

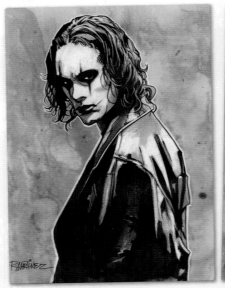

VIGILANTE
Sketch card by Randy Martinez

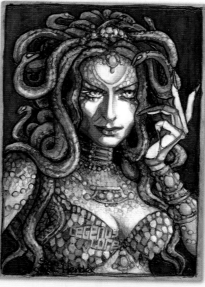

MEDUSA
Sketch card by Soni Alcorn-Hender

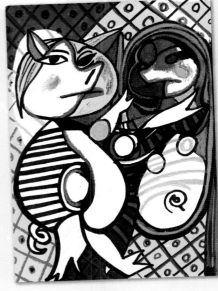

PIGCASSO
Sketch card by Randy Martinez

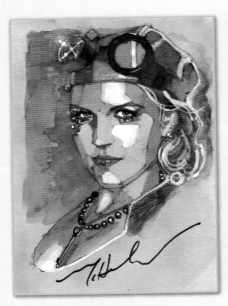

GIRL IN ACRYLIC
Sketch card by Mark McHaley

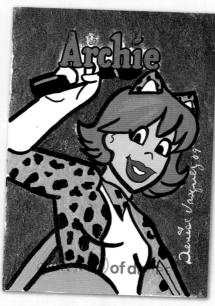

JOSIE
Sketch card by Denise Vasquez

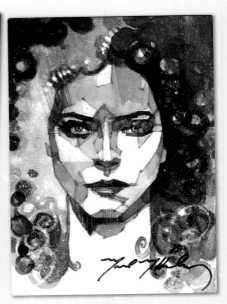

JULIET
Sketch card by Mark McHaley

Mixed-Media Materials

When creating any kind of art, don't limit your creativity to traditional art tools like paint or pencils. You can literally use anything you can fit on a sketch card. So far we've discussed graphite, pens, colored pencils and markers, watercolor and acrylic paint. As great as these mediums are on their own, there are endless combinations you can use to create mixed-media sketch cards—marker with colored pencil, watercolor with acrylic, graphite with colored inks, or any combination of just about anything. It helps to remember these simple rules for mixing mediums:

▶ **Water-based mediums** are not waterproof. When they dry they are still vulnerable to water.
▶ **Solvent-based mediums** are waterproof but vulnerable to other solvent mediums or products.
▶ **Wax-based pencils** resist water and solvents.

The best advice for a sketch card artist is get creative and experiment!

▼ Mixed-Media Supplies

Unconventional items are perfect for creating unique sketch card art. Items such as beads, glitter, feathers, sequins, ribbon, lace, glitter pens, crayons—anything! You can either use crayons as is, or use them as resists, or even melt them onto the art. The possibilities are endless.

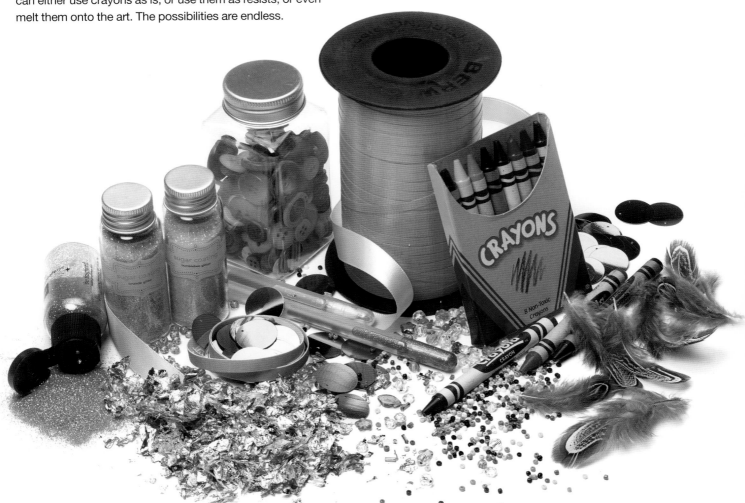

Mixed-Media

Mixed-media is when you combine more than one type of art material within one piece of art. When mixing mediums, remember that not all art materials work with one another. For instance, oil-based materials do not mix with water-based. Also, water-based materials will lift if you apply just about any wet medium on top. The best rule of thumb is to only use dry with wet mediums such as pastels over watercolor, or colored pencil over colored marker. In this exercise, let's render colored pencil over an astronaut drawn with colored markers.

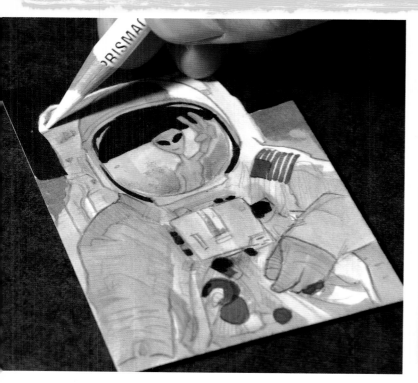

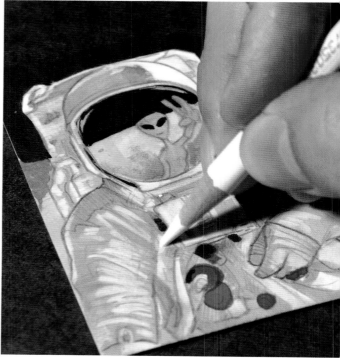

1 Always start with your lightest colored pencil, in this case, white. Light pencils over dark create nothing but mud.

2 Continue using the white pencil to draw in the highlights and reflective lights. Light colored pencils on top of dark marker create a nice layered effect.

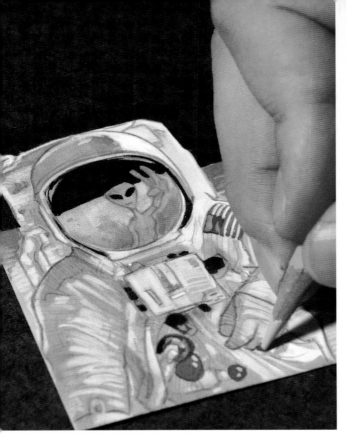

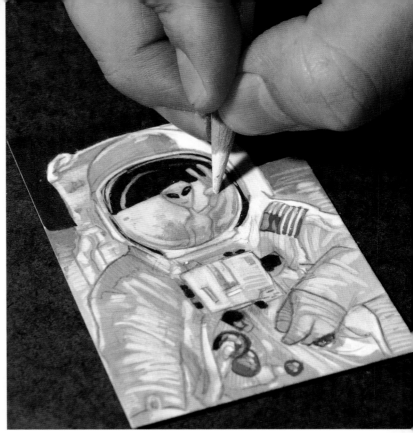

3 Draw in the highlights of your colored objects using light pinks and blues. Keep your pencil sharp to achieve the finer details.

4 Add highlights and details to the astronaut's mask and the reflection of the alien. With a white pencil, add the stars to the black marker of outer space.

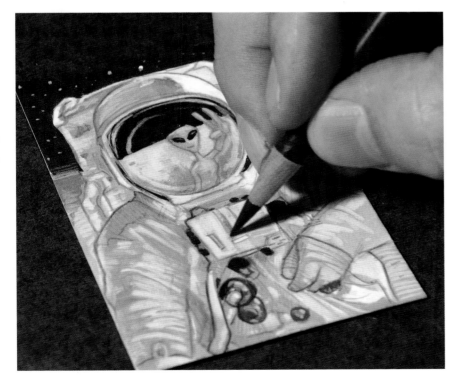

5 After the highlights are completed, add your darkest darks with dark brown, dark gray or Payne's Gray. Your color choices will always depend on your subject matter.

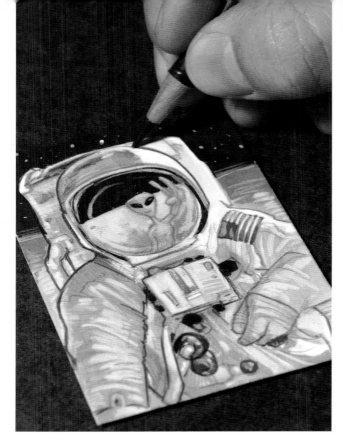

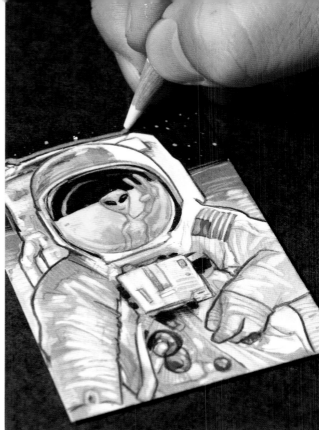

6 Putting a thin, dark line around your art will make the image pop away from the background. Keep your pencil sharp so you don't draw the line too thick.

7 Finish up your card by drawing in any remaining highlights or details you may have missed.

8 And there you have it, a mixed-media sketch card. Don't stop here though. You can use a number of different mediums in one piece of art. Sometimes the weirdest combos make the coolest effects. Don't be afraid to experiment!

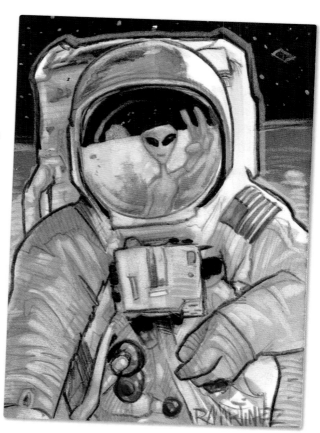

ASTRONAUT
Sketch card by Randy Martinez

MIXED-MEDIA
Sketch Cards

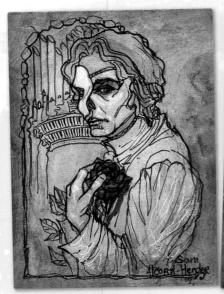

**VICTORIAN GOTHIC:
PHANTOM OF THE OPERA**
Sketch card by Soni Alcorn-Hender

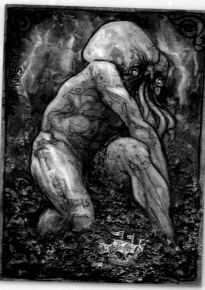

CTHULHU
Sketch card by Soni Alcorn-Hender

SNOWBOARD DESIGN
Sketch card by Alex Alderete

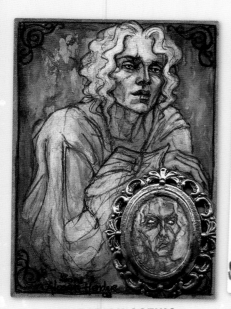

**VICTORIAN GOTHIC:
DORIAN GRAY**
Sketch card by Soni Alcorn-Hender

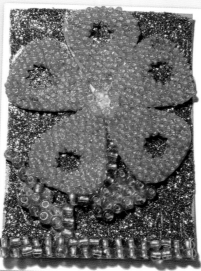

FLOWER: GUITAR PICKS & BEADS
Sketch card by Denise Vasquez

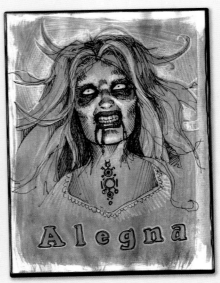

ALEGNA
Sketch card by Matt Busch

Designing and Constructing
YOUR PERSONAL SKETCH CARD

There is another side to sketch cards—literally. The back. Don't forget about that because the back of your sketch card is just as important as the original art on the other side. The back is space for you to promote yourself as an artist. Think of it as your business card with original art on the front. This chapter will teach you the secrets of how to design and construct your very own personal sketch cards, from composition to printing to cutting them just right.

The Back of a Sketch Card

The back of your personal sketch card is the first thing you should design. This will be your personal stamp on each and every card. It is important to design something that says something about you as an artist. A really great design can help you gain fans and get commissions. Many fans keep their cards in nine-pocket card sleeves with the art on one side and the backs on the other. The more appealing the back of your card looks, the more collectors will like to collect your sketch cards because the art looks great on both sides.

Include Your Business Information

One practical aspect of personal sketch cards is that they double as business cards. Include your website, email, phone number and any other contact info you want to give out to prospective clients and collectors.

Every time a collector or one of their friends looks at your sketch card, they have quick access to your business information.

It is also important to show an example of the styles you illustrate. A creative back can show other types of art or genres you may do. It's a great way to express yourself as well as advertise your services.

Getting Ideas for Your Card's Back

The back of your card can be anything you want it to be. It all depends on your creativity. Over the next few pages we'll cover some common types of card backs and show examples. Use card backs you have liked as inspiration but always strive to create your own idea and design. This will set your card apart from everyone else's.

▼ Three Types of Sketch Card Backs

There are three basic kinds of sketch card backs—logo back, info or bio card back, and a sample card back. It's important to create a design that works with your marketing strategy and is memorable to fans and collectors.

Logo card backs *get fans familiar with an image or design that represents you.*

Sample card backs *let fans see examples of your artwork in other genres and/or styles. It's a great hook to get people interested in your full body of work.*

Info or bio card backs *tell fans facts about yourself or information from your résumé.*

Using Sample Art on Your Card Backs

Putting samples of your art on the back of your card is a great way to show off your drawing or painting skills and advertise your talents. If you do several styles of art, you can include multiple samples of each style to represent that you have a broad range of style and appeal. You can arrange your art in a tiny gallery, or you can create a montage of your different styles interacting together. The more creative you can be, the better.

You can also create a variety of backs depicting each style. It depends on how you want to represent yourself as an artist.

Permissions

If you choose to use samples of work that have been published before, it is best to get permission before using them on your sketch card back. Most of the time companies appreciate your asking and will give you permission, but some companies have strict permission policies. So it is best to ask first.

Variations of Sample Card Backs

Randy Martinez has made a montage of his monster art, adding a humorous illustration of himself as the three wise monkeys' proverb. Denise Vasquez shares a bit about her personality on her sample card by illustrating peace, love and soul into her hair. The sample art cards of Luis Diaz demonstrate his talent and can double as logo cards.

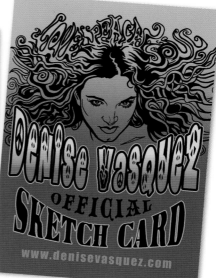

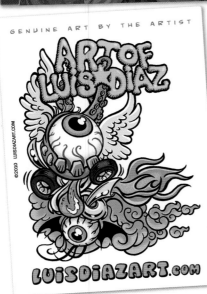

Logos

A logo is another tool you can use to brand yourself as an artist. It doesn't have to be too complicated, but it should make people think of you. A great concept is memorable, unique and to the point. Your logo should represent both you and your art. You can create variations of your logo to keep it fresh. Be aware of the basic image you want people to associate with your artwork.

Brainstorming Your Logo

To start, brainstorm as many ideas as you can about things you like and that you feel identify you: hobbies, favorite movies, music, comic books, nicknames, astrological signs, etc. Involving a friend in your brainstorm can be very helpful. Start a list and begin mixing and matching to create different ideas. Before you know it, you have a few logo concepts for your sketch card.

Use Your Image as Your Logo

One option for a logo is to use your own image. You yourself are unique, so anything with your face on it will most definitely be original. Use your personality as a selling point.

DON'T RELY ON OBVIOUS SYMBOLS

Paintbrushes, paint cans and pencils are pretty obvious symbols that convey art. What can you do to the paintbrush or pencil that will make it your own? Be creative. A good logo is unique, descriptive and simple.

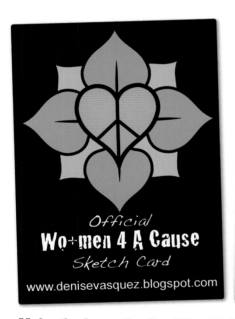

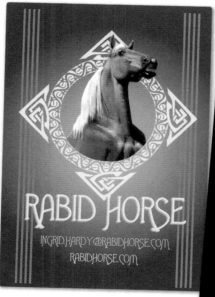

Make the Logo the Card Back's Main Focus

These card backs are good examples of strong logos. Denise Vasquez designed the Wo+men 4 A Cause card for a fundraiser, so the simple logo is displayed front and center. The Rabid Horse logo is used on the card back to advertise Ingrid Hardy's art studio. On the right, Alex Alderete enlarged his signature as his logo.

Info or Bio Sketch Card Backs

One of the most important elements to becoming a popular artist is getting in good with fans. While your art will always grab the most attention, a good public relations strategy will help keep fans interested and keep your art in the forefront of their minds. An info or bio sketch card back is a great way to let fans know a little about you the person. You are an individual and there are things about you, your tastes and your personality that your fans will be able to connect with.

Choose a Theme

You won't have a lot of space on the card, so choose a theme of information you want the fans to know about you. This could be favorite movies, artists who have influenced you, schools you have graduated from, any-thing that may interest people and start conversations. You never know who might read your card and find an interesting fact that they can talk with you about when they meet you in person.

Make a Tiny Résumé

You can also put your résumé on your sketch card back, such as a list of notable clients you have done artwork for. This will give your fans a road map to your other artwork. Just make sure you don't overload it with too much text and too little graphics. A good balance is best.

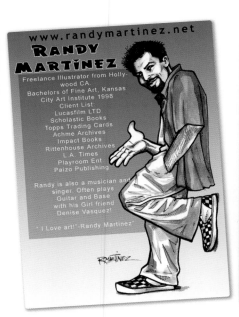

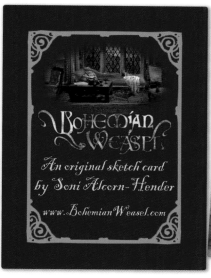

Spice up Your Card Backs With Relevant Personal Information

When including text on your card backs, the most important thing is to keep it interesting. Randy Martinez includes a client list alongside a cool self-portrait. Soni Alcorn-Hender enhances her pseudonym, Bohemian Weasel, with interesting borders, stylized fonts and a spooky photo of herself. At right, Nicole Falk uses a dialog bubble to call out her official website. Tiny details can be very memorable.

Composition

Good composition and design in your artwork says a lot about you as an artist. Think of composition as the overall collection of elements in a piece, and the design as the arrangement of lines, forms and shapes. A good composition is a balanced composition. You want to distribute the weight of all the elements to create a pleasing arrangement for the viewer's eye. Understanding what makes a good composition takes practice, but a few elements to consider are lines, symmetry, depth and subject placement. A centered image is a little boring, so be creative and experiment to find the right balance.

▲ Thumbnail Sketches

Thumbnail sketches are small, quick, rough sketches. The focus should be on composition and balance, not details. When planning your sketch card, draw as many as you need—the more the better. Choose your favorite one (or two), and develop the sketch gradually until you've got your idea nailed down.

▶ Unbalanced Compositions Disorient the Viewer

These compositions are unbalanced. The design on the left is very heavy on the bottom left. The design on the right has no flow, and the image hogs the background.

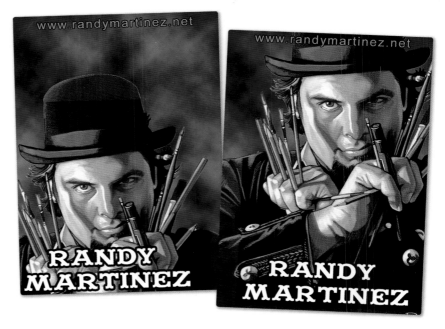

Tools for Working Digitally

Computers have become an important tool for artists today and are great for designing your sketch cards. In order to create professional-looking sketch cards, you will probably need to use one. If you do not have access to a computer or editing software, do not fret. Many schools have computers you can use. Ask the art teacher or librarian at your school if they have computers with graphics programs or photo editing tools you can use. You can also visit your local library and ask what programs they have on their computers. Many chain print shops have computers you can rent for an hourly fee. Also ask your friends if they have a computer with graphics or photo software. Or they may know someone who does.

Editing Software

The digital instructions in this book are from Adobe Photoshop, but the process will translate to most editing software. Many free tutorials are available online to help you get started with photo editing programs, and countless books have been written on the subject—check one out from your local library.

Scanners

Scanners are the standard tool illustrators use to record their artwork. When you are finished with your sketch cards, scan in your art at 300dpi, save it and then publish it on the Internet. Scanners do the best job of recording the color and detail of your art. Scanners are inexpensive and often cost less than a good digital camera.

Digital Photography

If you don't have a scanner, you can take photos of your artwork with a digital camera. Invest in a good camera with at minimum 8 megapixels. You want to capture as much of the natural color and detail as you can to make your art look its best. A tripod is great for stabilizing the camera so you get the best focus of your images.

MACRO FEAR
Sketch card by Len Bellinger

◄ Digitally Design Your Sketch Card Backs

Design your sketch card backs using digital editing software for an endless supply of colors, textures and effects. You can digitally create bright colors that are difficult to create by hand. Take care that all of the same rules of color and design apply to the computer as they do drawing and painting by hand.

Design a Sketch Card Back

After you've got a great idea for your sketch card back, it's time to pull it all together using a computer and photo editing software. If you are new to editing graphics in software such as Photoshop, pick up an instructional book for reference. It will take some time to get it down, but be patient and do your best. It's a learning process.

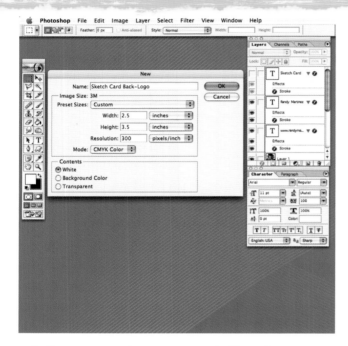

1 Open a new project or new page in Photoshop or another editing software. To create a blank image surface, enter the following settings and click OK:

Name: Sketch Card Back
Width: 2.5 inches
Height: 3.5 inches
Resolution 300 pixels/inch
Mode: CMYK

CMYK is the color mode that works best with printing. It limits the color palette to the four printable colors of cyan, magenta, yellow and black.

2 Using the type tool on your editing program, type in your name or the title of your studio. Choose a font that is interesting and expressive but easy to read.

Adjust the font size so that it fits on your card the way you like. Use your sketch template as a reference to position your font.

If you are making a bio card, create a new layer of text and type in your information. Be sure your text is no smaller than ten points; otherwise it will be very difficult to read. You can add outlines, change the font color or do whatever you like to your text, but wait until you've laid out the rest of the card.

Save your new file and leave it open.

3 Open your graphic file or files that will go on your card. Most likely your graphics will be much larger than the 2½" × 3½" (6cm × 9cm) surface of the card, so reduce the image size or crop the image to a size relative to the card back. Be sure to keep the resolution at 300dpi. Drag and drop the graphics onto the blank sketch card. This should create a new layer for each graphic you drag and drop into your project. Save and leave it open.

I usually leave my original graphics open in case I need them again. Simply put them aside or hide them from the screen. If you choose to close the files, the computer will ask if you want to save the changed files. Click No, and *do not save*. If you do, it will overwrite your original full-sized graphic with the adjusted one.

4 Edit each layer using the many tools in your editing software to clean up your graphics. Eliminate any unwanted background color and clean up the edges of your graphics so they are neat and precise. There are numerous free online tutorials and videos on how to use editing tools.

Using the eraser tool, delete all unwanted halos—the thin white lines that appear around the graphic when combined with the background. Zoom in to the affected areas. You want to remove only the halo and as little of the graphic as possible. Once you have cleaned up your graphics, save.

5 Using the move tool, reposition the graphics to their appropriate position on the card. Use your sketch as a reference.

You may find that some graphics are still a little too big. To resize, select the layer you want to adjust, then click Edit > Transform > Scale. Click and drag the handle bars (the tiny boxes that will show up on the edge of the image). You click and drag the handle bars to adjust the size of your image. To keep the original proportions of your graphic while scaling, hold down the Shift key while adjusting. When you get it to the size you want, double click on your graphic. It may ask if you wish to apply changes. If you like the adjustments, then click Yes and save.

7 Flatten the image and save a copy of your design as a JPEG. Click the Layer tab to flatten the image. Then click Save As to save your file as a JPEG.

6 Now that you have everything positioned correctly, you can experiment with the different effects and filters in your editing software. You can add outlines, drop shadows, textures and even bevels using the Layer Style under the Layer tab. You can also add blur effects, distort your graphics using filters, or change the intensity of the color or contrast. The possibilities are endless. After you finish putting on all your bells and whistles, save it.

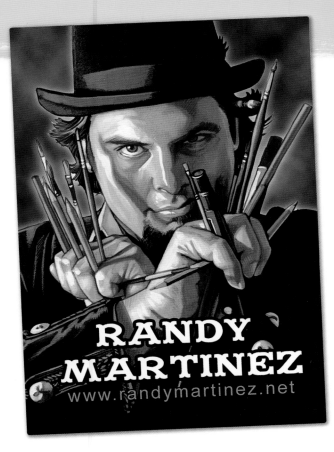

8 Congratulations! You have just created your first sketch card back design. The next exercises will teach you how to create a sheet and construct the actual cards.

Create a Sheet of Sketch Card Backs

So you have a killer design for the back of your sketch card. The next step is to create a sheet of sketch card backs. We're going to make a sheet of nine cards on one sheet of 8½" × 11" (22cm × 28cm) paper using a computer and editing software.

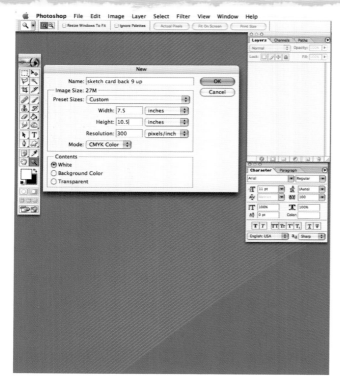

1 Open a new project or new page in your photo editing program. When you are prompted, use these settings for the image size:

> Name: 9-up Sketch Card Backs
> Width: 7.5 inches
> Height: 10.5 inches
> Resolution 300 pixels/inch
> Mode: CMYK

2 Open the JPEG copy of your sketch card design in your editing software.

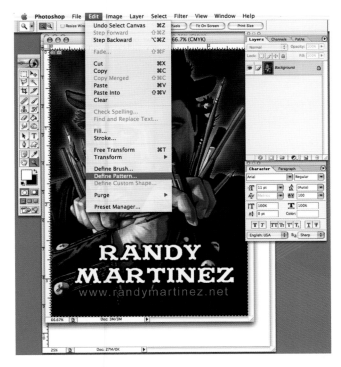

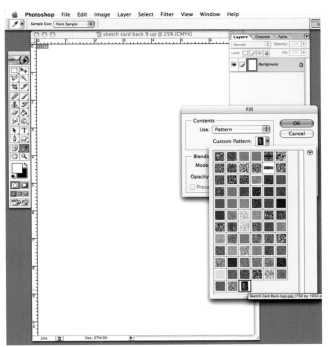

3 Click on the sketch card back. Under the Select tab click Select All, then under the Edit tab click Define Pattern.

4 Select the blank page. From the Edit menu, select Fill. In the pop-up window select Use > Pattern. Choose the pattern you defined in step 3; it will look like your sketch card and be on the bottom of the list. Click OK.

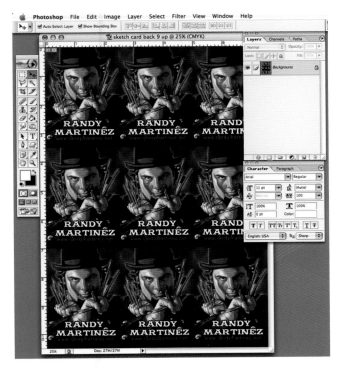

5 Like magic, your page is now filled with nine sketch card backs, perfectly fitted onto your page. Hit Save. Congratulations! You have just finished creating your first page of sketch card backs! Read on to learn about the benefits of having your card backs printed professionally.

Basics of Printing

When printing your sketch cards, you want them to look as professional as possible. Finding a good print shop is a great way to accomplish this. Following are the main components to look for when choosing a print shop.

Color Copier

For your sketch cards, you'll need to find a good print shop with a color copier. In general, you want a printer whose color copier is no more than five years old. Brand-new printers are not always the best, but a copier made within the last four or five years is definitely better than one from ten years ago. Simply ask the printer how old their color printers are.

Seek out the Right Print Shop
You may have to shop around to find a print shop that can meet all of your printing needs. If you need something, don't be afraid to ask!

The print shop you choose should have their color copy machine hooked up to their computer system. It is not good enough to simply plug a memory stick into a copier because all kinds of color correction needs to take place. Any good print shop will have a computer to load your art into the computer so it can "rip" it, in other words convert your art file into a format specifically for their printer.

High-Resolution Printing

You will need to print your art at the highest resolution and clarity, so ask to see recent samples from their machines. Some will even make you a proof print for free to show you how your art will look out of their machines, so always take an art file with you (on a disc or memory card) when shopping for a good print shop.

Color Correction

Because your art needs to look as good as possible, you need to find a printer who is willing to work with you concerning color correction. It means you may have to hang around the print shop while they print out test runs, but it's worth it. There is nothing worse than getting a whole run of prints back too dark or too red or too something. A good print shop should have no problem working with you and letting you see proofs before they do a final run of prints. The more return business you bring, the more they will be happy to help. If they aren't cool with it, find someone else.

Convenience

Convenience is not so much a necessity, but if you print a lot, it can save you a lot of time to find someone close to where you live or work. Some print shops even have the ability to let customers upload files to the Internet and create your order right online. I recommend digitally uploading your files to a printer only after you have established that they print your art well.

Often print shops can save your personal print settings. After you have gone into the shop and worked with them to get your print just the right color correction, they will save your settings. This is great because

you can have 100% faith that your printing will always meet your expectation.

What to Ask For
Once you have found a good printer, take your digital art files (either on CD or memory stick) and give it to the printing tech. Ask for color copies printed at the highest resolution on regular color copier paper.

Borders
A page of nine sketch cards is exactly 7½" × 10½" (19cm × 27cm), which leaves a ¼-inch (6mm) border space on the top and the bottom of the page and a ½-inch (13mm) border on the sides.

Do not adjust the size of your file or image. Often printers will shrink your file to fit in the bordered area, but this will make all of your card backs the wrong size. Print out and measure the proof sheet to make sure the card size is accurate. Now that everything is set, make your order. Tell them how many prints you need and ask when they will be ready.

Picking up Your Prints
Inspect your prints when you pick them up. Ask for a replacement or to not be charged for bad prints. If everything looks OK, smile and thank the printer for all their hard work. Developing a good relationship with your print shop is always a smart move.

Printing at Home
Printing at home is an option, but the quality and types of printers vary widely. The ink used with standard home inkjet or bubble jet printers is not water resistant and is subject to smudging. Color laser printers work similar to color copy machines but are expensive. It's more practical to find a print shop with a good color copier.

Cutting and Mounting Tools

You'll need a few tools to precisely cut your sketch cards to size.

Rotary Trimmers

The rotary trimmer is the safest cutting tool on the market. Rotary trimmers glide along a rail fastened to a cutting board that has ruler marks. These trimmers are easy to use and the cutting blade is not exposed.

There is a full range of trimmers available from professional grade to everyday use and in different sizes and prices. The trimmer you choose should have each of these features:

- cutting base large enough to measure an 8½" × 11" (22cm × 28cm) piece of paper
- ability to cut through card stock
- built-in precision ruler
- paper clamp to hold your paper in place while cutting
- easy and safe blade replacement

If you are not able to buy a rotary trimmer, not to worry. Most print shops have them. Most large chain print shops provide them for self-service.

Spray Mount Adhesive

To fasten your sketch card backs to the different papers for the artwork, you will need to securely bond different papers together. Your glue needs to be waterproof and spread evenly without leaving bubbles. Spray mount is a strong waterproof glue that is applied in an even spray. For sketch cards, choose an acid-free, waterproof, permanent spray mount that will bond and never lose stickiness. Always use spray mount in a ventilated area.

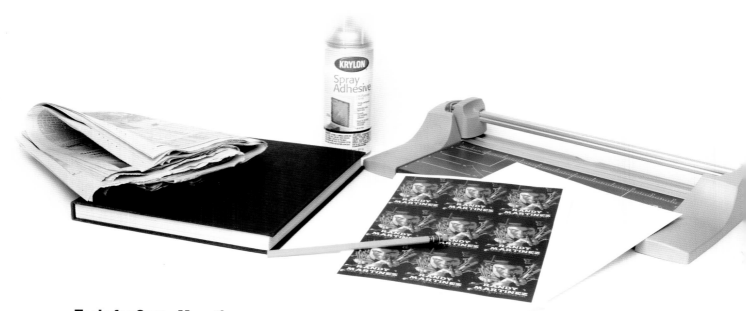

Tools for Spray Mounting
From left: newspaper, book to press glued pages together evenly, spray mount adhesive, pencil, sheet of card backs, sheet of paper for artwork and rotary trimmer.

Mounting the Card Back

Now that you have your sketch card backs printed nine on a sheet, you are ready to construct your sketch card. You will need all of the materials listed on the previous page.

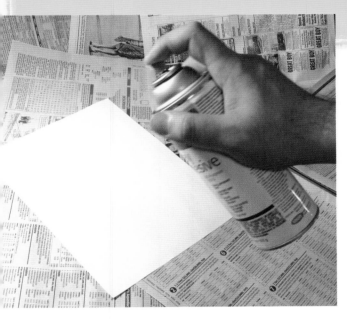

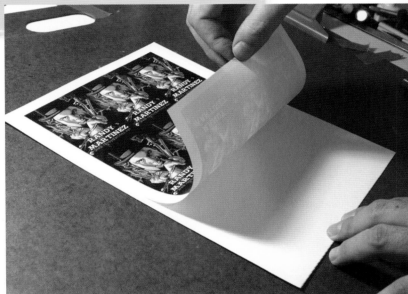

1 Put your sheet of sketch card backs face down on clean newspaper. Spray an even layer of spray mount on the blank side of the card. Use a generous amount without allowing the glue to pool—about two seconds of spraying. Spray about 6 to 8 inches (15 to 20cm) away from the paper.

2 Carefully pick up the sheet of sketch card backs by the corners and lay it glue-side down on the drawing paper of your choice. Line up the sketch card backs with the drawing paper starting at the upper left corner. While holding the bottom side of the sheet off the drawing paper, slowly let the top edge of the card backs make contact with the drawing paper toward the upper right corner.

Once you have the upper edge in contact with the drawing paper, slowly let the rest of the sheet make contact with the drawing surface. Use a rolling motion starting from top to bottom. You should now have your card backs looking back at you. It's OK if the card backs are not lined up perfectly to the drawing surface. Just make sure none of the sketch card image is off the paper.

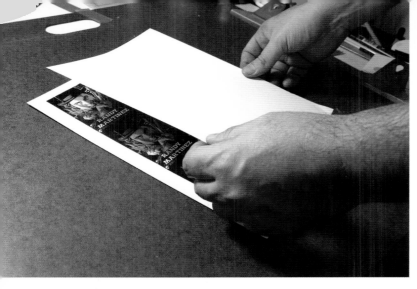

3 Immediately lay a clean, blank piece of paper over your sheet of cards. Starting from the inside out, gently press down the sheet of paper. This will securely press your sketch card backs and your drawing surface together.

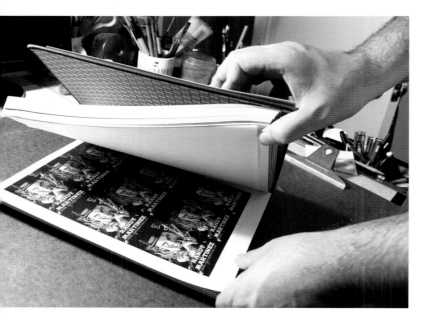
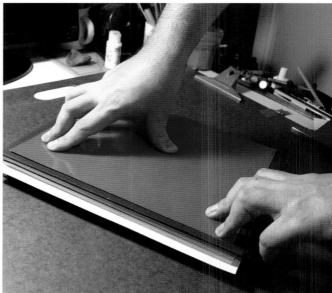

4 Place your newly made sheet of cards in the center of a heavy book. Close the book and let it sit for a few minutes to evenly press the two sheets of paper. Carefully remove your sheet of cards, and let it sit for five to ten minutes. Once the glue dries completely, you are ready to cut the sheet up.

ONE SHEET AT A TIME

If you are making multiple sheets of cards, make the sheets one at a time so the glue stays workable. It's very important to change the newspaper after spraying each sheet of card backs with spray mount. This will help keep each card clean.

Cutting the Sketch Cards

Cutting your sketch cards correctly is the most important part of this process. Bad cuts ruin your cards. Learning to make correct measurements and precise cuts will serve you well as a sketch card artist.

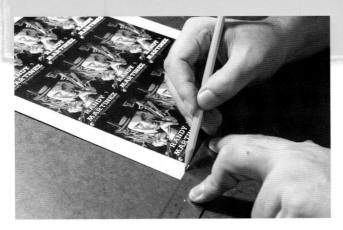

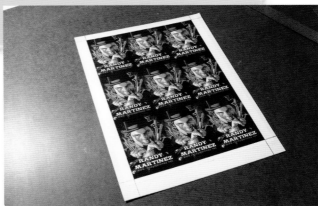

1 Removing the border is the first step to cutting your sketch cards. Use a sharp pencil and a ruler to mark the exact edges where you want to make your cuts. Repeat this step for every side of your sketch cards. Draw light lines between the rows and columns of cards. There will be eight lines in all.

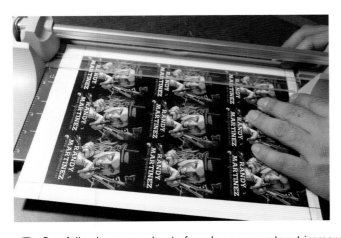

2 Carefully place your sheet of cards on your rotary trimmer with the sketch card back up. The sheet should slide easily under the plastic guard of the trimmer. Line up the pencil marks on your sheet of cards with the blade. Use the measurements and lines on the board to align the sheet of cards.

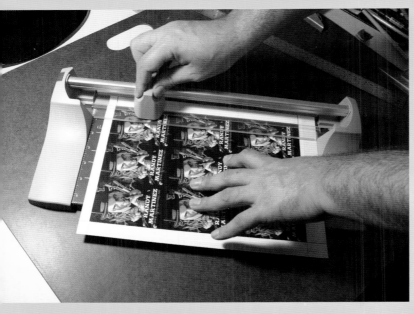
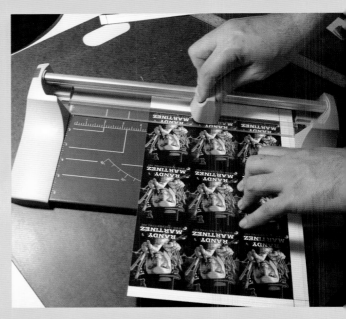

3 Carefully slide down the trimmer arm to cut off the excess border. Trim away the borders on all four sides.

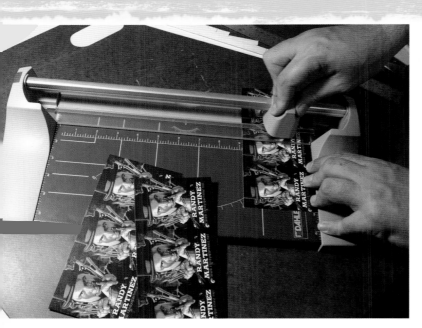
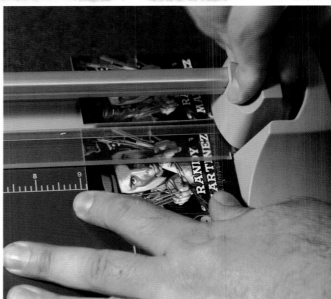

5 Cut along the vertical edges of the three strips of cards. Make sure you use the rulers on the cutting board to ensure precise cuts. Rotate the cutter as needed to keep your hands and wrists comfortable and stable.

6 Keep making cuts until you've got a pile of nine perfect sketch cards. Take your time and do not rush to make your cuts.

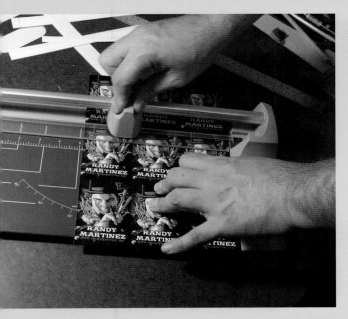
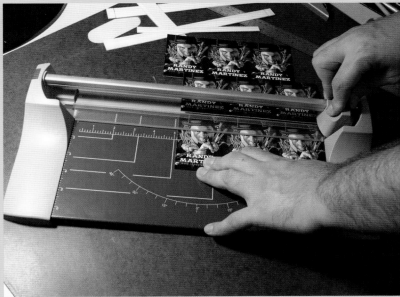

4 Cut along the horizontal edges of your cards to create three strips of three cards side to side.

7 Congratulations! You have created nine perfectly cut sketch cards ready to draw on! Next we'll discuss how to store and protect your finished sketch cards.

Protecting and Storing Your Cards

No one wants a sketch card that's torn, creased or damaged. Protecting your sketch cards from harm is necessary so you can share your artwork with family, friends and fans. The better condition your sketch card is in, the more valuable it will be and become over time!

Card Sleeves

A card sleeve is a thin, clear, polypropylene, acid-free holder. Simply slide the card into the opening. It's an easy way to prevent your sketch card from being scratched.

Top Loaders

For added protection, place the card sleeves in a hard plastic top loader. Like the sleeve, it also has an opening at the top to slide the card sleeve in. Use both the card sleeve and top loader for protection against bending, tearing and creasing.

Boxes and Binders

There are a few options for carrying more than one sketch card with you. You can keep your sketch cards in the sleeves and gently pile them, one at a time, into a

Soft Sleeves

These thin, clear, acid-free polypropylene sleeves help prevent scratches and protect your cards from dust. Plus, they are inexpensive.

Top Loaders

Top loaders are hard plastic sleeves that protect your cards from bending, tearing or creasing. Many collectors place a soft-sleeve-protected card inside a top loader for extra protection.

Plastic Card Storage Boxes

These clear plastic storage boxes are great for storing a lot of blank sketch cards at one time. Avoid using these boxes to store your completed sketch cards—you do not want your original artworks pressed against each other.

small, plastic card storage box. This is helpful if you plan on attending a convention. This is also a good way to keep your blanks organized, accessible and clean.

You can also place multiple cards in a collector's album or a three-ring binder. These come in many styles, sizes and colors, and at reasonable prices. Special album sheets are made for three-ring binders. These protector sheets usually have four to nine pockets on each page. Look for different types of collector's albums at hobby shops or online.

Hard Cases

If you see the value of your sketch cards as an investment and are willing to spend a little more for better protection, hard plastic cases protect your cards from most types of damage. They can be magnetic or held together by screws or even sonically sealed so they can't be opened. A number of companies offer services for professional seals and certification. Search online or ask someone at a hobby shop for recommendations on preserving your sketch cards.

Colored Soft Sleeves

These colored soft sleeves are slightly more rigid than standard soft sleeves and add a decorative touch to storing your cards. These are typically used for card gaming but work for sketch cards, too.

▲ Three-Ring Binders and Collector's Albums

Binders and albums are a great way to store your cards as well as transport them. To use a three-ring binder you will need to buy trading card protective pages. They are available anywhere trading cards are sold. Collector's albums are bound binders with card protector pages bound directly into the book.

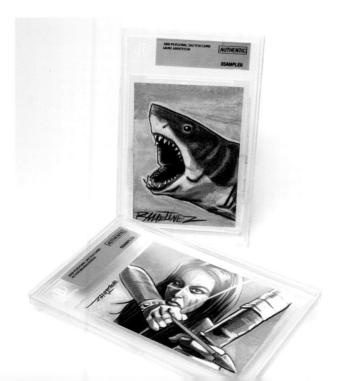

◄ Artist Sketch Card Encapsulation

Encapsulation is the best way to protect and authenticate your finished sketch cards. The capsules are made of archival-safe, acid-free polystyrene and are UV protected to guard against fading. These capsules are not meant to be opened.

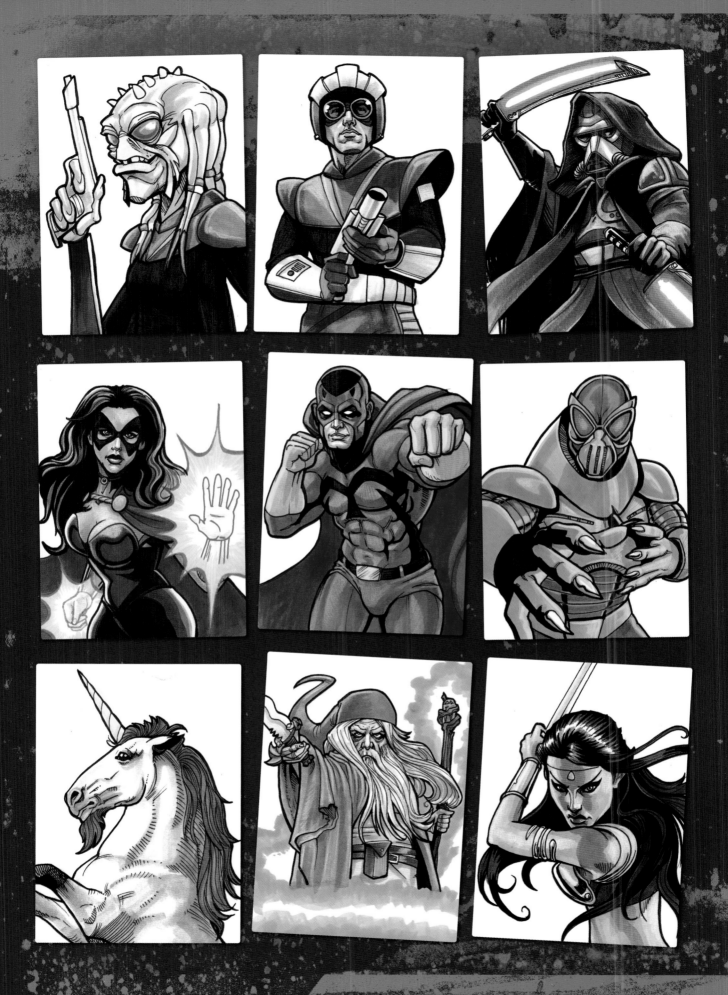

Sketch Card DEMONSTRATIONS

All the sketch card demonstrations in this book are completed with the same basic steps. You'll notice that the first three steps in each demonstration show red, blue, green and purple lines, sometimes over gray lines. The colored lines do not mean that you should use colored pencils. The red and blue lines show what you are drawing in that particular step, while the gray lines represent what has already been drawn in previous steps. The most important thing to remember is that you should always draw lightly until the final step—not so light that you can't see the lines, but light enough that you can erase the lines easily.

COLOR KEY FOR DRAWING

Draw your lines in the following order:

1 red
2 blue
3 green
4 purple

The gray colors represent previously sketched lines. You will erase the lines you don't want and darken or ink the ones you want to keep.

1 Sketch the Initial Figure
With a very light graphite pencil, quickly sketch the position and pose of the subject. You don't need much more than a stick figure at this point, so just start with the basics. (Remember you can use a compass, ruler and other tools to draw basic shapes and lines.) Draw some guidelines on the head so you'll know where to place the facial features when you add details later. You can also draw small circles to indicate any joints.

2 Add the Main Shapes
Use the same pencil to sketch the largest shapes that make up the subject's head and body. They don't have to be perfect; keep the drawing loose for now. Remember to think in terms of basic shapes.

3 Add the Small Shapes and Details
Using your original guidelines for placement, add the smallest shapes and details. At this point your drawing might look confusing and messy, but that's OK because you'll erase most of the lines after you add the final details.

4 Ink the Drawing
Switch to a darker pencil and draw over the lines you want to keep. (The lines should still be light enough to erase but dark enough to stand out from your structure lines.) This is the time to tighten all of the loose shapes you've sketched. Ink your sketch card drawing with a fine point permanent ink marker or pen. Draw in only the lines you want to keep. First the most important lines, then the smaller details.

5 Color the Sketch Card
When you are satisfied with the drawing, you're ready to add color. Stay creative with your medium choice and use your imagination!

Space Hero

Captain Cosmo Starfire is the squad leader of Alpha Squadron. A bona fide hero of the Galactic Federation, Cosmo Starfire has led his troops against the evil band of warlords called Dark Nova. A skilled warrior and crack pilot, Cosmo has bravely foiled the many plots of Dark Nova's evil warlord, Strath Kull. Cosmo is the Galactic Federation's greatest hero, so be sure to draw him confident and proud.

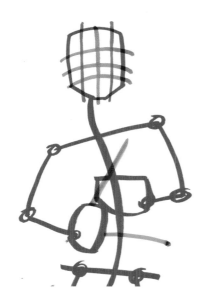

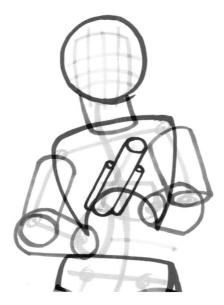

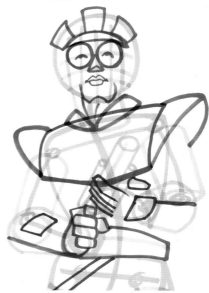

1 Sketch the Initial Figure

Start by drawing a quick gesture drawing of the space hero—a basic stick figure with small circles marking the bone joints. Use a box shape for the head and rectangles for the hands.

Draw guidelines on the head so you will know where his facial features will go. A simple stick gun is good for now.

2 Add the Main Shapes

Draw the rib cage (upper torso) and hips. Make a circle around his head for the helmet.

Use cylinders for the upper arms, neck and forearms. Basic cylinders also work for the body of the gun.

3 Add the Small Shapes and Details

Add the smaller details such as fingers, facial features and the chest plate. Use the guidelines from step 1 to place the eyes and mouth.

Give your space hero a strong chin and place the shoulder pads and collar. Continue drawing details such as his belt and helmet.

Finally, add some details to the gloves.

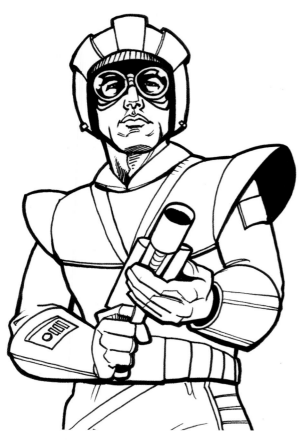

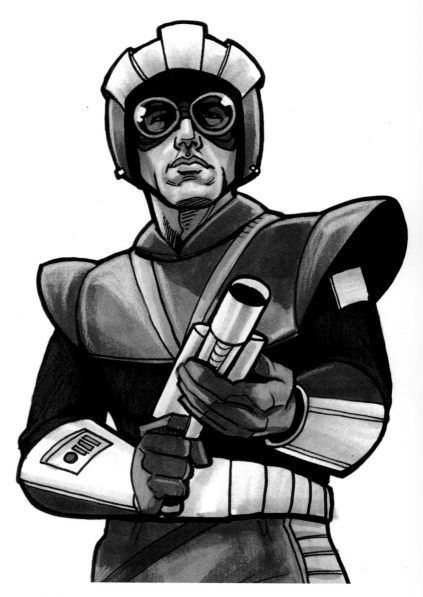

4 Ink the Drawing

Add smaller details such as stripes on his pants, gun and facial characteristics. Use a black pen or marker to fill in the solid dark areas. Erase the lines you no longer need and ink your drawing.

5 Color the Sketch Card

Choose a coloring medium and have fun giving your space hero a really out-of-this-world outfit and crazy blaster.

PROFILE
SPACE HERO

The science-fiction hero is generally the manifestation of everything good we try to be. Honorable, loyal, heroic, courageous, optimistic and compassionate. While it is not always easy, the hero always keeps to his morals. The appearance of the sci-fi hero is usually clean and a contrast to the bad guy. He uses technology but is not dependent on it. The hero usually succeeds because he possesses the spirit and will to do good.

Space Alien

Zed Lepplin is a Galactic Federation warrior from the planet Kashfleer. Zed is also the best friend of Cosmo Starfire and first lieutenant of Alpha Squadron. A master of weapons and engineering, Zed's skills have saved Cosmo from many lethal situations. His love of rock music and his humorous demeanor are the perfect contrast to Cosmo's stoic persona. Zed is funny and cocky, so be sure to draw him with attitude and spunk.

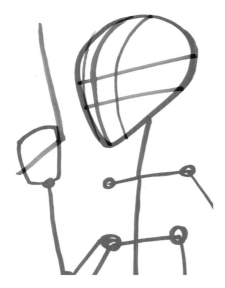 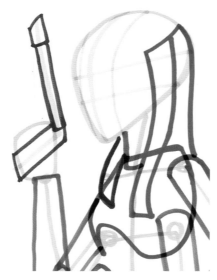 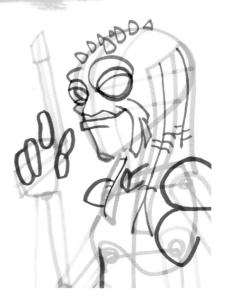

1 Sketch the Initial Figure

Start by drawing a quick gesture drawing of the alien—a basic stick figure with an egg shape for the head, circles for the joints and a rectangle for the hand.

Draw guidelines on the head so you'll know where his facial features go.

2 Add the Main Shapes

Draw the rib cage and head tails that hang down like pieces of ribbon. Draw cylinders for the arms (three are visible) and neck.

Draw a cylinder for the forearm. Form the body of the gun with some rectangles.

3 Add the Small Shapes and Details

Add the smaller details including the fingers, facial features and shoulder pads. Use the guidelines from step 1 to place the eyes and mouth.

Continue drawing the facial features like the eyes and facial growths. Add the lower torso by drawing a line from his rib cage to the bottom of the card. Continue drawing details to make your alien even more funky!

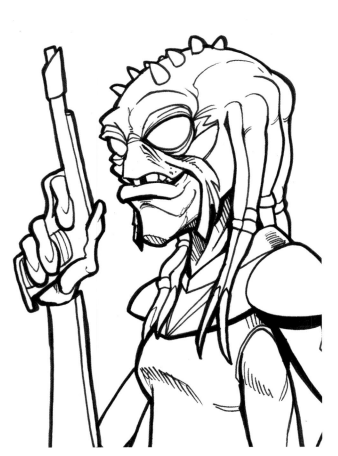

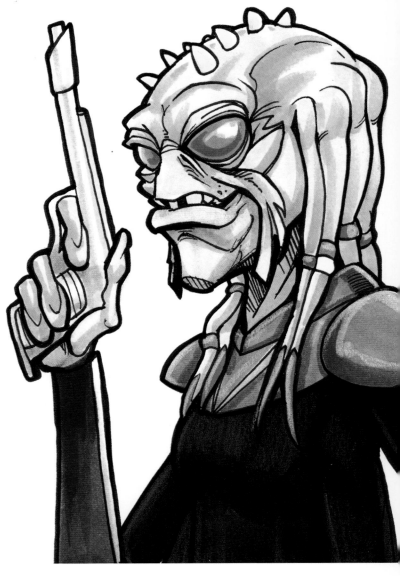

4 Ink the Drawing
Add smaller details like textures on his skin, gun details and facial characteristics. Use a black pen or marker to fill in the solid dark areas. Erase the lines you no longer need and ink your drawing.

5 Color the Sketch Card
If you used a permanent ink marker or pen, you should be OK to use almost any coloring medium. If you use colored markers, be sure the black ink is nice and dry first. The great thing about science fiction is that there are no rules—so go crazy. Make your alien any color you want!

PROFILE
SPACE ALIEN

Aliens make great science-fiction sidekicks; they make a nice contrast to the stoic hero. Aliens have very specialized skills that help the hero survive. Even though they look intimidating, aliens can offer comic relief and show compassion for life.

Space Warlord

The Galactic Federation has but one nemesis, Dark Nova. Leading Dark Nova toward their quest of galactic domination is Strath Kull. Strath Kull is a master of evil magic and wields two ancient weapons from the Shi'Vos system called Energy Cutless. Strath Kull's archenemy is his half brother Cosmo Starfire. On top of his quest for galactic dominance, Kull lives to one day take revenge on his half brother, whom he hates with the passion of a burning sun. Strath Kull is evil and wicked; be sure to draw him dark and menacing.

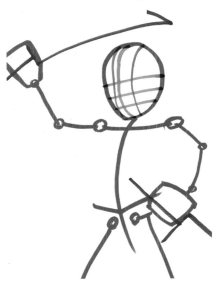

1 Sketch the Initial Figure

Start with a quick gesture drawing of the space warlord—a basic stick figure with an egg shape for the head and circles to mark the joints. Rectangles work well for hands.

Draw guidelines on the head to place facial features later and add simple sticks for the laser swords.

2 Add the Main Shapes

Draw the rib cage and triangles for the hood and pelvis.

Draw cylinders for the arms and a triangle for his breathing mask. Then draw a smaller triangle to add form to the breathing mask and a heavy brow.

Add form to the laser swords.

3 Add the Small Shapes and Details

Add the smaller details such as his fingers, mask features and shoulder pads. Use the facial guidelines to place the eyes and mouth. Don't forget to draw the lasers that shoot from the swords.

Continue drawing the mask features and the robe, belt and chest plate.

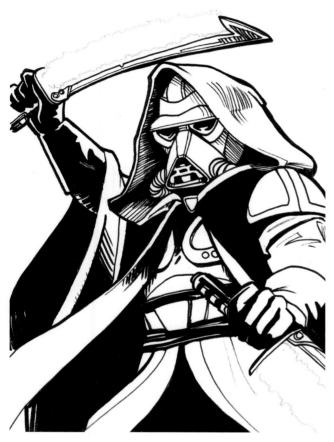

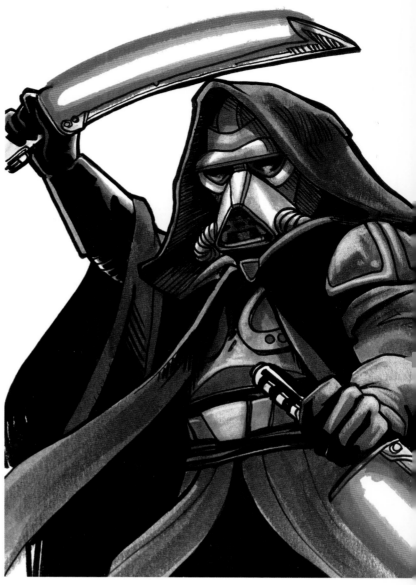

4 Ink the Drawing

Add smaller details like textures, buttons and knobs, sword details, and folds in his robe. Use a black pen or marker to fill in the solid dark areas. Erase the lines you no longer need and ink your drawing.

5 Color the Sketch Card

Choose a coloring medium and have fun. To make your warlord dark and scary, use a variety of blacks and dark grays for his outfit.

PROFILE
SPACE WARLORD

Bad guys in science fiction are dark and brooding. They represent corrupted power and are often dependent on technology, which can end up being their weakness. Intimidation and control through fear are tactics used by bad guys to dominate the universe.

Wizard

The Wizard Dralthion is from the great mountains of Shard. Over 500 years old, Dralth is the wisest and most powerful wizard on 100 planes of existence. Dralth is a rogue, standing only for himself and the way of life. He is not evil, he is not good, he simply is—as a tree is a tree or a rock is a rock. Dralth is ancient, so be sure to draw him with wisdom and eyes that have seen it all.

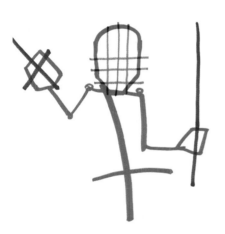 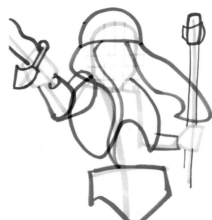 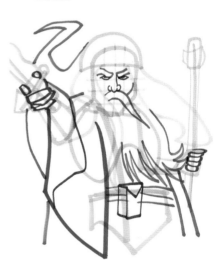

1 Sketch the Initial Figure

Start by drawing a quick gesture sketch of the wizard—a basic stick figure with circles marking the joints. Use a box shape for the head and rectangles for the hands.

Draw guidelines on the head so you will know where his facial features will go. Add simple sticks for the staff and sword.

2 Add the Main Shapes

Draw the rib cage and make a half circle over the head for the wizard's hat. Then draw his lower torso and hips.

Use cylinders for the arm segments and draw long flowing shapes for the hair.

Add form to the staff and sword using a variety of basic shapes.

3 Add the Small Shapes and Details

Add the smaller details including the fingers, facial features and his robe. Use the guidelines from step 1 to help place the eyes and mouth.

Draw a long flowing beard and mustache, and add more detail to the robe.

Give him big eyebrows and a long pointy hat. Finish the details of the robe and add a belt and a little pouch for the wizard's magic dust.

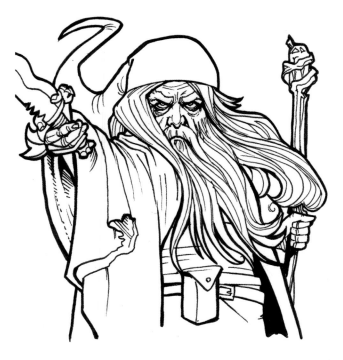

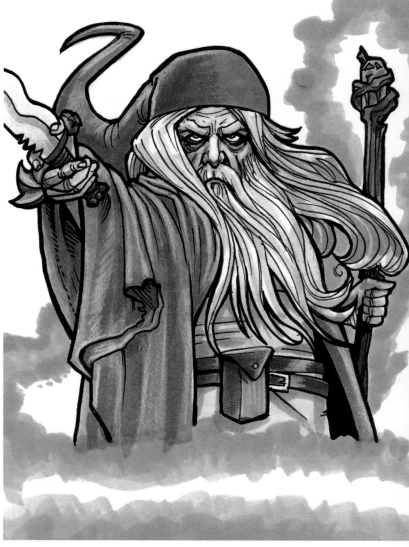

4 Ink the Drawing

Add smaller details like skin texture, hair and facial characteristics. Use a black pen or marker to fill in the solid dark areas. Erase the lines you no longer need and ink your drawing.

5 Color the Sketch Card

If you used a permanent ink marker or pen, you should be OK to use almost any coloring medium. If you used colored markers, be sure the black ink is nice and dry first. There are no rules in fantasy art, so have fun. Color some spooky green magic coming out of his wizardly staff.

PROFILE
WIZARD

Wizards are wielders of all things magic and mystic. Typically, wizards are drawn with long flowing beards to suggest age and wisdom. But wizards can also look like anybody because their magic allows them to appear however they want.

Unicorn

Unicorns are some of the most magical creatures ever. It is felt that their magic comes from the single golden horn that extends from the forehead. While extremely powerful, unicorns want nothing more than to live in peace and play. Unicorns are beautiful, elegant creatures, so draw them with graceful strokes and delicate features.

 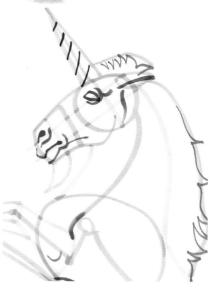

1 Sketch the Initial Figure

Start with a quick gesture drawing of the unicorn—a basic stick figure with circles for the joints. Use a circle and a square for the head.

Draw guidelines on the head so you will know where the unicorn's facial features will go and a simple line for the horn.

2 Add the Main Shapes

Draw the upper torso and connect the two parts of the head with an upper and lower jawline.

Connect the head and the upper torso with two sloping S-curves. Draw a cylinder for the upper legs of the unicorn.

Again, use cylinders for the lower legs. Give the unicorn an ear and a cool-looking goatee.

Add form to the horn and draw the mane with some S-curves. Don't worry about the hair details yet.

3 Add the Small Shapes and Details

Add the smaller details such as facial features. Use the guidelines from step 1 to help place the eye, nostril and mouth.

Continue drawing the facial features and legs. Add detail to the hair, mane and horn. You'll add the really fine details while you pencil and ink your drawing in the next step.

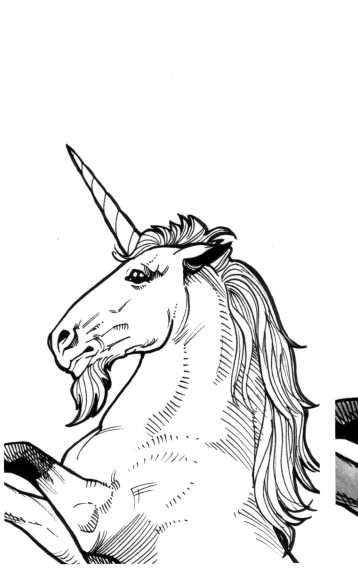

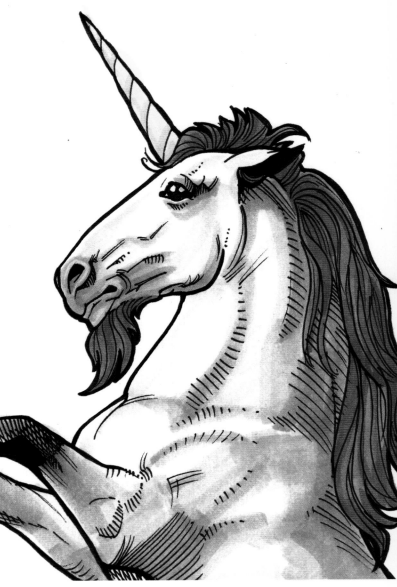

4 Ink the Drawing

Add smaller details like fur and shadows to the mane and goatee. Use a black pen or marker to fill in the solid dark areas. Erase the lines you no longer need and ink your drawing.

5 Color the Sketch Card

Choose a coloring medium and have fun. Get creative with mixing mediums and add some glitter to your unicorn's horn.

PROFILE
UNICORN

Unicorns are basically horses with a horn out of their heads. They have lots of personality yet are very vain. They know they are beautiful creatures, and they always make sure they look their best. Be sure to always draw them with well-groomed manes and flowing goatees.

Elf Warrior

Princess Nym is an elf warrior from the deep forests of L'Anka. Nym is protector of the forest and possesses great power. She draws her energy from the great trees. As beautiful as she is dangerous, foes often underestimate Nym's sword skills. Despite her prowess as a warrior, Nym is a proponent of peace and harmony. She would be happy to never draw her sword again. Nym is one with nature, so be sure to draw her powerful but focused and centered.

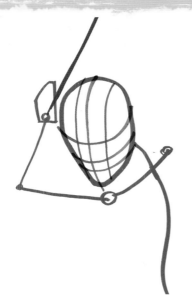
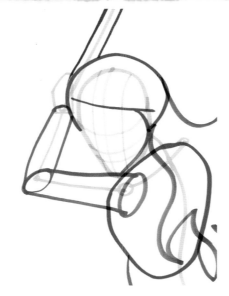
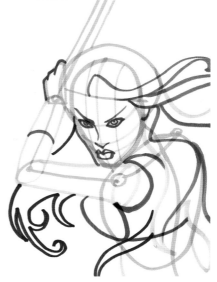

1 Sketch the Initial Figure

Start by drawing a quick gesture sketch of the elf warrior. Create a basic stick figure with an egg shape for the head, rectangles for the hands and circles for the joints.

Draw guidelines on the head so you will know where her facial features will go. Add a single line for the sword.

2 Add the Main Shapes

Draw the rib cage noting that her back will be showing. Draw a C-shape around the top of the head for her hair.

Use cylinders for her upper arm and some wavy lines for her long, flowing hair.

Draw a cylinder for her forearm and complete her midsection from the rib cage to the bottom of the card.

Add form to the sword with lines on either side of the original line.

3 Add the Small Shapes and Details

Add the smaller details such as her knuckles, facial features and the breast armor. Use the guidelines from step 1 to help place the eyes and mouth.

Add eyebrows and give the right side of her face a little definition. Detail the hair with long flowing shapes. Create the lower torso with a line from her rib cage to the bottom of the card. Give her a wrist guard and a shoulder pad.

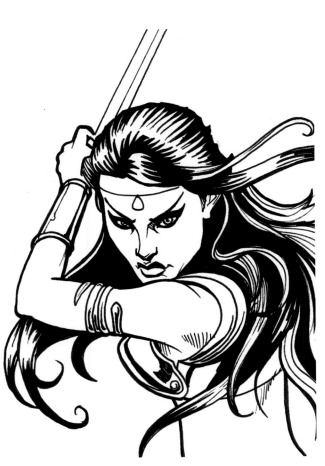

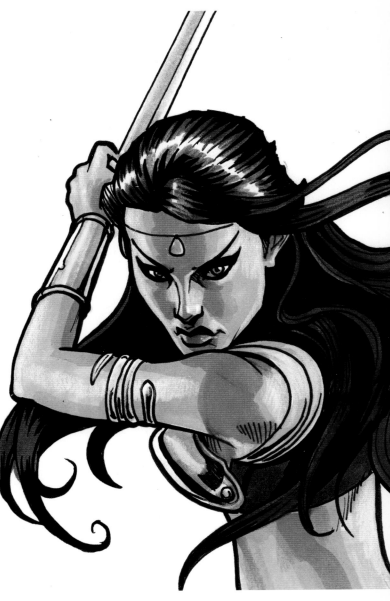

4 Ink the Drawing

Add smaller details like hair, facial details and reflections on the armor. Use a black pen or marker to fill in the solid dark areas. Erase the lines you no longer need and ink your drawing.

5 Color the Sketch Card

If you used a permanent ink marker or pen, you should be OK to use almost any coloring medium. If you used colored markers, be sure the black ink is nice and dry first. Have fun coloring. Vary the armor from shiny to old and weathered.

PROFILE
ELF WARRIOR

Elves appear in all forms of mythology and fantasy. They are similar in appearance to humans. They are immortal as well as natural athletes and warriors. Elves are also known for possessing mystical powers and are spiritually connected to nature, which includes stone and precious metals.

Basketball Player

Basketball is a fast-paced, exciting and athletic sport. Players in the game are constantly moving—running, jumping, shooting baskets and, of course, dunking. The slam dunk is the most exciting play in the game because players can show off some style and showmanship. Basketball is a game of finesse, power and focus, so be sure to draw your basketball players determined and explosive.

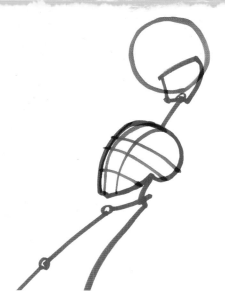

1 Sketch the Initial Figure

Start with a quick gesture drawing of the basketball player—a basic stick figure with small circles marking the bone joints. Use a square for the hand and an egg shape for the head. Note that his right arm seems to come out of his head and is quite short. This is OK because his arm is bent behind his head where you can't see it.

Draw guidelines to use later when you place the eyes, nose and mouth. Don't forget to draw the ball.

2 Add the Main Shapes

Draw the upper torso, hairline and ear. Take note that his face is in profile, so use the guidelines from step 1 to guide you.

Draw the left upper arm and neck, plus a small cylinder for the right forearm. Cylinders will help you visualize the 3-D form.

Draw a big shape for the open mouth. Save the mouth for last since it's a small detail.

3 Add the Small Shapes and Details

Add the smaller details including his thumb on the ball, facial features and a little muscle definition on his arm and shoulder. Use the guidelines from step 1 for placing the eyes, nose and lips.

Draw his eyebrows, teeth and ear. Add more muscle definition on his left forearm. Draw the back of his jersey and add the collar. When people have big expressions, there are a lot more lines and shapes than normal, so gradually place more facial detail.

Add sweat bands for flair and an arm hole in the jersey. Finally, draw seams on the basketball.

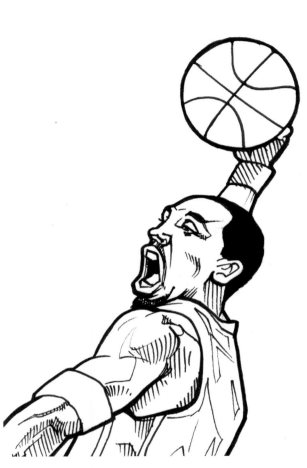

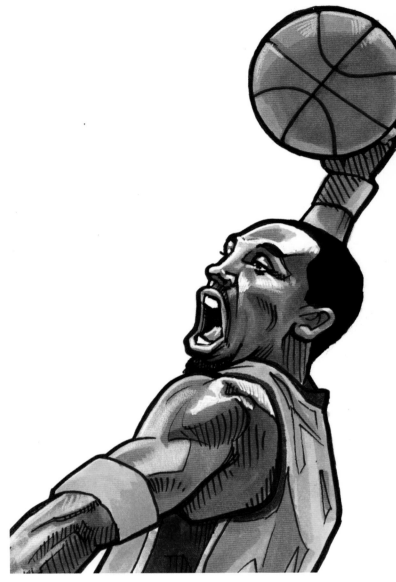

4 Ink the Drawing
Add smaller details like facial hair, jersey design and fabric folds. Use a black pen or marker to fill in the solid dark areas such as his hair. Erase the lines you no longer need and ink your drawing.

5 Color the Sketch Card
Choose a coloring medium and have fun. Look up some of your favorite team colors on the Internet for real-life color accuracy.

PROFILE
BASKETBALL PLAYER

Basketball players are tall, long and very athletic. Because of the amount of running they do, most basketball players are lean and muscular. Be sure to draw basketball players with defined muscles and movement. Use reference photos to study the proper form of the jump shot and the many different twisty-turning poses players make as they drive to the basket.

Baseball Player

The game of baseball requires a variety of skills from being able to catch and throw, to being able to hit a hard, round ball with a long wooden bat. Some of the first collectible cards were produced for the game of baseball, and it continues to break new ground in the trading card industry. Baseball players are very focused so be sure to draw your baseball player confident and ready.

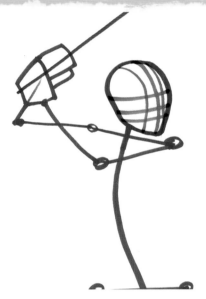

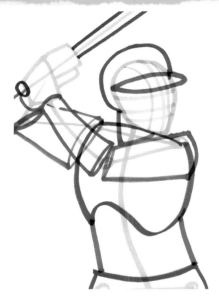

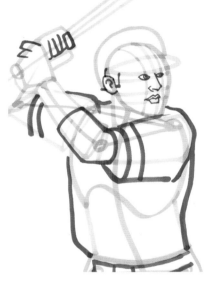

1 Sketch the Initial Figure

Start with a quick gesture drawing of the baseball player's batting pose.

Draw a stick figure with circles marking the joints. Draw in guidelines on the head for facial feature placement.

After you've gotten the gesture correct, add in a stick for the baseball bat.

2 Add the Main Shapes

Draw the rib cage and a C-shape around the head for the helmet, then draw the hips and waist.

Draw cylinders for the upper arms and neck, then put in the visor of the helmet.

Add cylinders for the forearms. His right arm will be foreshortened because it is bent toward the foreground, so don't worry if it seems stumpy in your sketch. Connect the hips and rib cage to make his torso.

Finally, add form to the bat and use a small oval shape under his hands for the knob of the bat.

3 Add the Small Shapes and Details

Add the smaller details including his fingers, the shirt and facial details. Use the guidelines from step 1 as reference for the eyes, nose, mouth and ear.

Draw the sleeves and belt and some of the smaller details like the ear.

Finally, add details like his elbow pad, stripes on his shirt, the belt buckle and his sideburns.

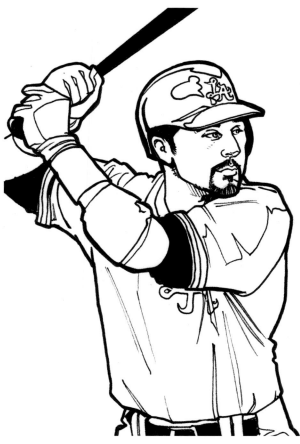

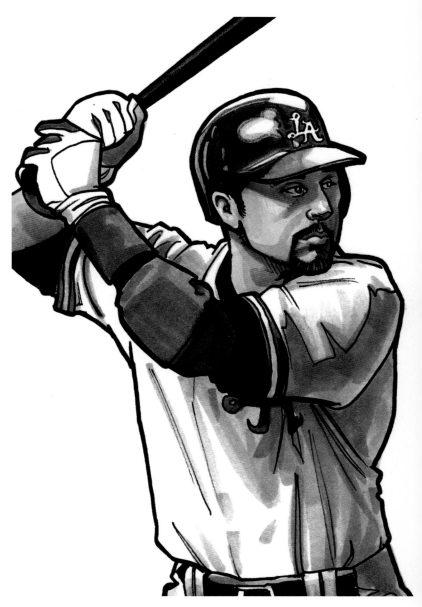

4 **Ink the Drawing**
Add smaller details like hair and facial detail or reflections on the helmet. Use a black pen or marker to fill in the solid dark areas. We live Los Angeles, California, and chose the LA Dodger's logo, but you can use any team or logo you like. You can even make up your own. Erase the lines you no longer need and ink your drawing.

5 **Color the Sketch Card**
Choose a coloring medium and have fun. Look up some of your favorite team colors on the Internet for real-life color accuracy.

PROFILE
BASEBALL PLAYER

Baseball is about proper form and mechanics. When drawing baseball players, whether fielding or hitting, proper stance and form is important. It's helpful to use reference pictures of baseball players to get it right.

Action Hero

Detective Sam von Scott does not play by the book. Hard grizzled from fighting crime, Sam uses rough tactics to deal with scum. *Whatever it takes* is his motto, and he's not afraid to put himself in harm's way to get to his man. Detective von Scott is always jumping through glass windows or something that makes him a mess. So be sure to draw him with scars, dirt and even a little blood.

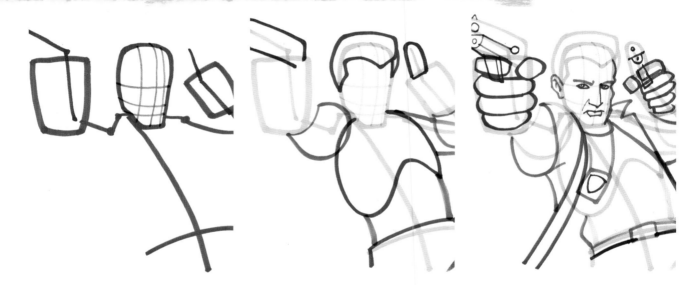

1 Sketch the Initial Figure

Start with a quick gesture drawing of the action man—a basic stick figure with circles for the joints, squares for hands and a box shape for the head. Note that his right arm is foreshortened, so it will appear short in the foreground.

Draw guidelines on the head so later you can place the eyes, nose and mouth.

Draw simple stick guns. The right gun is forward, so it will be foreshortened like the arm.

2 Add the Main Shapes

Draw the rib cage, waist and hips, and then add his hair. For now, draw his hair as one big shape as if he's wearing a helmet.

Draw his left upper arm with a box shape. Connect his rib cage to his hips to make a lower torso, and draw cylinders for the forearms.

Draw rectangles to add form to the guns. On the left gun, use a bit of an arch at the top of the rectangle.

3 Add the Small Shapes and Details

Add the smaller details such as his fingers, facial details and the opening of his coat. Use the guidelines from step 1 to help place the eyes, nose and mouth.

Add details to the eyebrows, ear and smile line. Give him a belt, and add a badge hanging from a necklace. Give the left side of his face a little more definition. He's been through a lot of action, so he should look nice and chiseled. Finish off his coat so that it fits a little loose.

Finally, add details to the guns. It's up to you how much or how little.

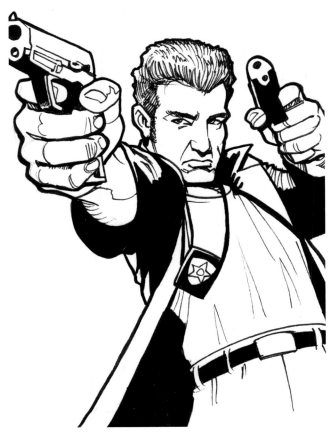

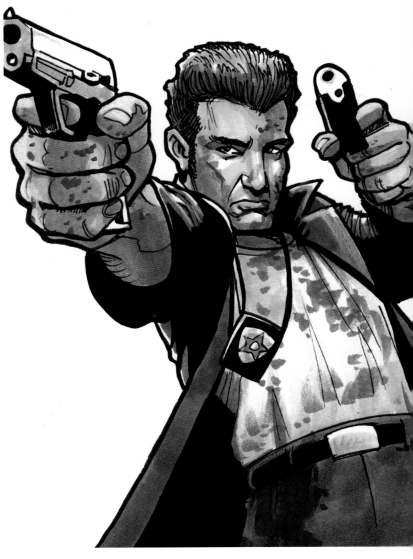

4 Ink the Drawing

Add smaller details on the badge and the folds in the shirt and coat. Use a black pen or marker to fill in the solid dark areas. Erase the lines you no longer need and ink your drawing.

5 Color the Sketch Card

Choose a medium and have fun coloring. Is he a gritty cop? Make him dirty, with evidence of blood and smoke. Is he a super slick cop? Make him sparkling clean—give him guns that shine! Go back and give him different outfits, scars or hair styles.

PROFILE
ACTION HERO

Action heroes have no regard to the clothes they wear, the people around them or private property. Their focus is on getting the bad guy. But action heroes are clever and inventive, so they should always be performing an over-the-top task. Scars, dirt and blood make great details for action heroes.

Adventure Girl

Dakota Jules lives for adventure. While most supermodels travel the world for fashion shows, Dakota is exploring ancient ruins risking life and limb for ancient artifacts. A Harvard scholar, Dakota has unraveled the earth's most vexing mysteries. Adventure never looked so good. Dakota spends a lot of time in jungles and ancient ruins. Be sure to make her beautiful but dusty and well traveled.

1 Sketch the Initial Figure
Start by drawing a quick gesture sketch of the adventure girl—a basic stick figure with circles marking the shoulders and an egg shape for the head.

Foreshortening can be tough, so let's keep this really simple. Use a rectangle for her fist and another smaller rectangle for her thumb. Draw guidelines on her head so you will know where her facial features will go.

Now draw a simple stick gun. It is pointed toward the front, so put it through the box fist you just drew.

2 Add the Main Shapes
Draw the rib cage first, then the brim of the hat. Don't draw the brim too low; you don't want to cover her eyes.

Draw a cylinder shape for the top of the hat and a circle to indicate her upper arm. It's bigger than the forearm because her sleeve is rolled up. When you draw the breast, use the rib cage as reference. It should finish at the bottom of the rib cage. Draw some lines that indicate hair and a line for her neck.

Just like with the upper arm, draw a circle for the foreshortened forearm. Then draw a line for the top of the backpack. Give the gun shape by making an arch-shaped box.

3 Add the Small Shapes and Details
Add the smaller details including the fingers, the dip in the top of the hat, the hat band, facial details and a collar. Use the guidelines from step 1 to help place the eyes, nose and mouth.

Continue drawing the facial features and her pupils, as well as hat details and fingers. Draw a strap that connects to the backpack.

Finally, add a little hole for the gun barrel.

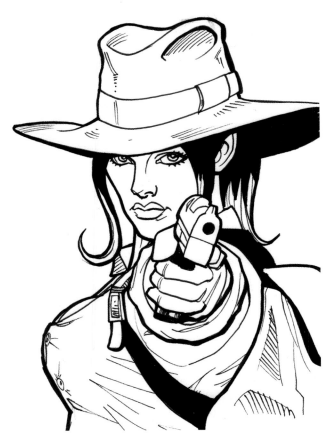

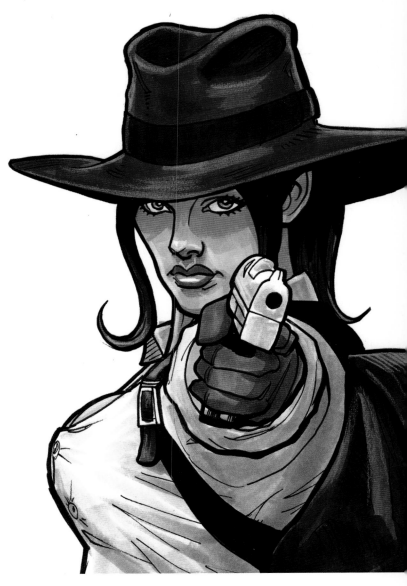

4 Ink the Drawing
Add smaller details on the gun, as well as shirt folds and hair texture. Erase the lines you no longer need and ink your drawing.

5 Color the Sketch Card
Choose a medium and have fun coloring. You can color your adventure girl clean and unscathed, or make her look like she's been in some dark, dirty places with a few spots of gray or light browns. Maybe even some scars.

PROFILE
ADVENTURE GIRL

Adventure heroes wear practical attire suited to the environment they are exploring. They are often exposed to wild animals, insects and the elements, so they must be able to move quickly to avoid danger. Keep that in mind when creating your hero's outfit.

Superhero

In a time of uncontrollable crime and injustice comes a champion to protect the good people of the world. Night Raven, the ultimate superhero, can soar through the air and has the strength of 100 bull elephants. Nothing will stop Night Raven from cleaning up the streets and protecting the earth from peril. Be sure to draw your superhero with a very proud and stoic expression.

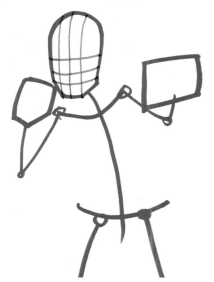

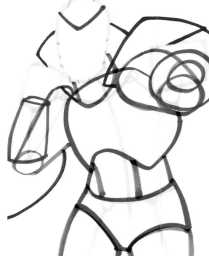

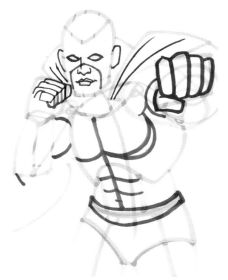

1 Sketch the Initial Figure
Start a quick gesture drawing of the superhero—a basic stick figure with a domed box shape for the head. Be sure to make the bottom jawline squared off. Rectangles will work for the hands.

Draw guidelines on the head so you will know where his facial features will go.

2 Add the Main Shapes
Draw the rib cage and pelvis, and then draw the top of his mask.

Draw cylinders for the upper arms, neck, legs. Then give him some abs.

Just like with the upper arm, draw a cylinder for the forearm. His left upper arm will look stumpy because it is foreshortened. Then start drawing his big and wispy cape.

3 Add the Small Shapes and Details
Add smaller details such as fingers and facial features. Use the face guidelines from step 1 to place the eyes and mouth.

Continue drawing his mask, knuckles, chest and muscle definition. Give him some nice-sized biceps. He's very strong!

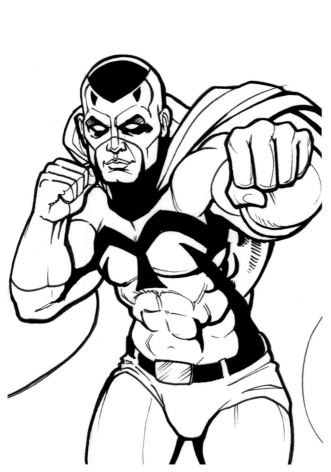

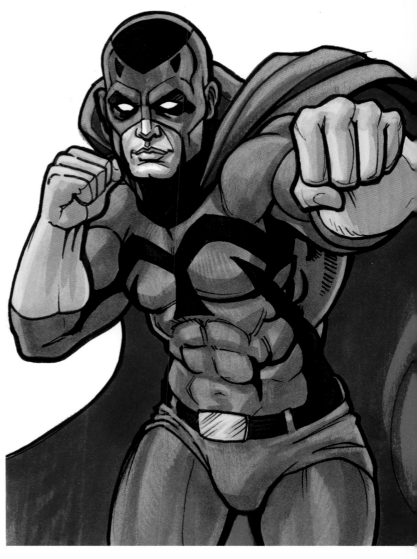

4 Ink the Drawing
Add smaller details like a logo across his chest, muscle definition, cape folds and facial expression. Use a black pen or marker to fill in the solid dark areas. Erase the lines you no longer need and ink your drawing.

5 Color the Sketch Card
Choose a medium and have fun coloring. Some superheroes wear bright colors with big capes. Here we used the primary colors, but experiment with unique combinations.

PROFILE
SUPERHERO

When drawing superheroes always remember that they are bigger than life. They are usually bigger and taller than the average human, and their costumes are exciting and colorful. Capes are typical apparel of the superheroes—sometimes they serve a purpose and sometimes they are just for show.

Superheroine

The Violet Star is a mutant heroine who uses cosmic energy blasts to combat evil forces against the people of earth. She possesses the ability to rocket through the sky at supersonic speeds and can create a supernova blast that will destroy everything that surrounds her. The Violet Star often works side by side with Night Raven to combat the master villain, The Emerald Weasel.

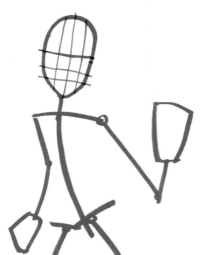

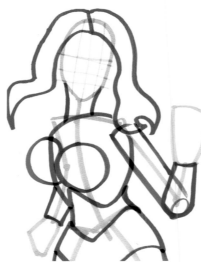

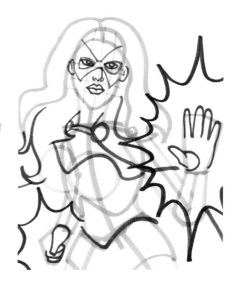

1 Sketch the Initial Figure

Draw a quick gesture sketch of the superheroine—a basic stick figure with circles for joints and an egg shape for the head. Rectangles work well for the hands.

Draw guidelines on the head so you will know where her facial features will go.

2 Add the Main Shapes

Draw the rib cage and pelvis, then add long flowing shapes for the hair.

Use cylinders for the upper arms and neck. Draw the breasts and attach her hips to the rib cage.

Just like with the upper arm, add cylinders for the forearms.

3 Add the Small Shapes and Details

Add smaller details such as fingers, facial features and hair strands. Use the guidelines from step 1 to place the eyes and mouth.

Continue drawing facial features like the ears and add a cape, mask and costume.

Lightly draw light bursting from her hands.

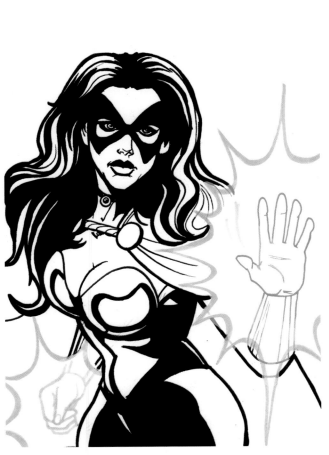

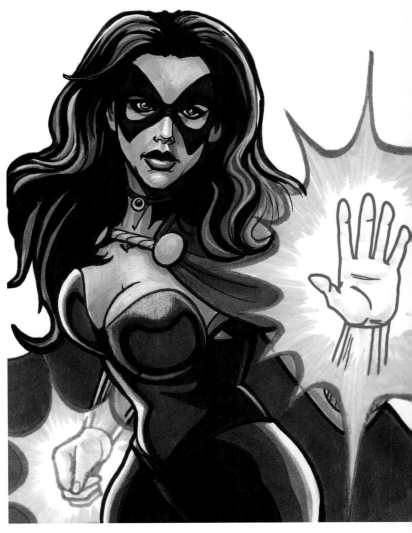

4 Ink the Drawing

Add smaller details to her costume, hair and facial expressions. Use a black pen or marker to fill in the solid dark areas. Erase the lines you no longer need and ink your drawing.

5 Color the Sketch Card

Choose a medium and have fun coloring. This superheroine uses shadows to her advantage, so she wears dark colors, but you can make her costume any color you want.

PROFILE SUPERHEROINE

Superheroines are bigger and stronger than the average human. They are in top physical condition and possess delicate beauty. Superheroines are typically on top of current fashion and always look great. Make sure to draw superheroines powerful yet elegant.

Super Villain

The Emerald Weasel is known as the most ruthless and dangerous super villain to terrorize the earth. Possessing no natural superpowers, this evil genius has engineered a lethal and impenetrable suit of armor. The lightweight armor gives The Emerald Weasel the ability to fly at high speeds and wield superhuman strength. The Emerald's armor is equipped with sonic weapons and deadly claws to combat his arch enemy, Night Raven.

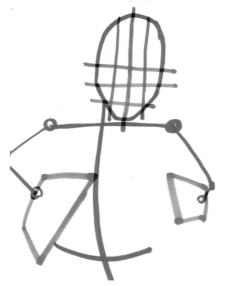

1 Sketch the Initial Figure

Start with a quick gesture drawing of the super villain—a basic stick figure, circles for joints and an egg shape for the head. Rectangles work well for the hands.

Draw guidelines on the head so you will know where his facial features will go.

2 Add the Main Shapes

Draw the rib cage and hips. Use an almost diamond shape for his breath mask.

Draw cylinders for the upper arms and shoulder pads, then the foreshortened forearms. He has big neck armor, so draw that covering most of his shoulders.

3 Add the Small Shapes and Details

Add the smaller details such as his fingers and his goggles. Use the guidelines from step 1 to help place the eyes. Continue drawing the facial features like the eyes and mouth grate.

Finally, add his nails and belt. Don't forget to give him a thumb.

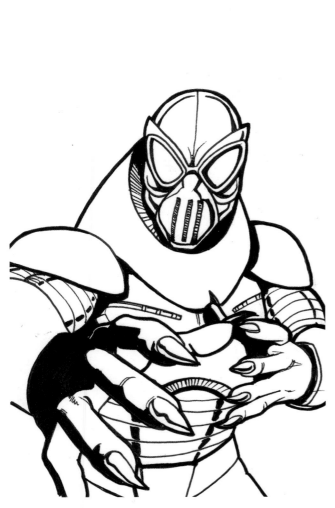

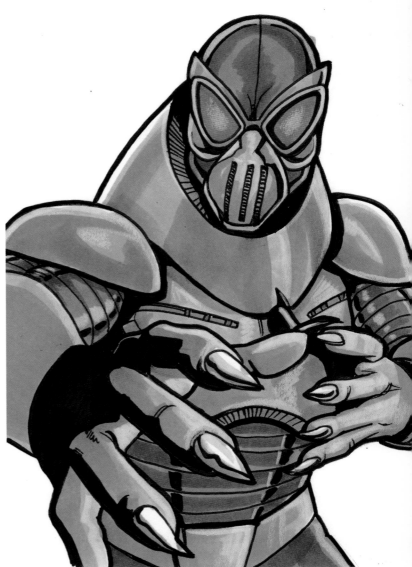

4 Ink the Drawing
Add smaller details like armor pleats and reflections. Use a black pen or marker to fill in the solid dark areas. Erase the lines you no longer need and ink your drawing.

5 Color the Sketch Card
Choose a medium and have fun coloring. This bad monster is bright green, but you can make him dark and in shadow. It really depends on your mood and your monster's mood.

PROFILE
SUPER VILLAIN

Super villains must always possess an ability that contrasts with, but is equal to, the superhero. Generally the difference comes down to morality. Some villains are mad geniuses plotting a ruthless gauntlet of challenges for the superhero. Super villains are usually over the top—big and intimidating, crazy and dangerous, unpredictable and cunning. Draw your super villain as someone you'd avoid in a dark alley.

Introduction to
SELF-PROMOTION

Years ago, it was customary for artists to share their creations at art shows and conventions, or gatherings of friends, family and peers. But as we've transitioned into the digital age, endless opportunities have opened up for artists to connect and share their work. The Internet especially has allowed us the freedom and control to self-promote our art. Establishing yourself as an artist via the Internet may seem like a daunting task, but like anything, the more hard work and research you put into it, the more results you will see and the easier it will become. Self-promotion is an art form in itself.

Facebook Bunch

Promoting yourself is creating a network of people. The more people you connect with, the larger your network. And the larger your network, the more opportunities you will have to reach more people.

Starting a Website

The Internet has changed the way we communicate as artists. We can share our art, collaborate and network with other artists, and chat with others anywhere, at any time! Establishing a presence on the Internet is the best way to promote yourself as an artist! It will help people worldwide discover who you are and how to find you and your art.

Email

Before you start a website, you'll need an email address. You can use your email account to start a website, share your artwork, send out newsletters and build a fan base. This is an easy way to send and receive messages over the Internet. If you don't already have an email address, there are many free services out there where you can set one up—Gmail, Yahoo! Mail or Hotmail. Simply create your username and password and you're on your way!

Choose a Domain Name

Once you have an email address, it's time to set up your home base: your website. A domain name is the physical address on the Internet that directs people to your website. You can use whatever name you'd like for your domain name, but for artists, it's best to stick to your real name—or the name you use as an artist. Using your real name makes it easier for fans, friends, peers and prospective clients to find you on the Internet. It also helps to turn yourself into a full-fledged brand!

If, when you go to sign up for your domain and it's taken, try alternatives that use an art-related term. For example, janedoeart.com or artistjanedoe.com. Something simple and straightforward will identify you as an artist and help people find you.

Registering and Hosting Your Domain Name

Once you decide on your domain name, you can go to sites like www.godaddy.com or www.register.com. You can get a domain name for a reasonable price (under ten dollars) at these and other sites, and some even offer web hosting service. Web hosting is the business of providing storage and other services for websites.

The hosting service maintains and stores your website files on their server space so that your website stays up and running for the world to see.

To set up your website, do an Internet search for free website builders and hosting. Many web hosts offer templates to help you build your website, while offering unlimited storage space for your files, a free domain name, tech support and more. Some of these sites have limitations, and some place advertisements on your site in exchange for their services. One site we've found, Yola (www.yola.com), offers a free website and hosting with no ads though you may pay to upgrade for fancier features.

Homepage

What you post on the Internet creates an image of who you are to your audience. Being genuine, honest, pleasant, confident, passionate and professional on the Internet is just as important as it is in person. Your homepage is the first page your visitors will see. It should give your visitor a sneak preview of who you are.

About Me

Your website should include a bio page or an About Me section explaining your background as an artist. This is a good place to include your artist's statement if you have one.

Résumé

If you have professional credentials, include a link to your résumé somewhere on your website. Include everything you think would interest fans and prospective clients.

Q *How long have you worked at Topps?*
A On my twelfth year.

Q *What was the first sketch card set released by your company?*
A *Marvel Legends.*

Q *What sketch card sets have you worked on?*
A As an editor: *Marvel Legends, Garbage Pail Kids (GPK), Terminator Salvation* and *WWE 2009.* As an artist: *Lord of the Rings* (two series), *Garbage Pail Kids,* Topps Baseball (mostly promotional and development).

Q *How many artists are on your roster?*
A One hundred or so.

Q *How do you find artists to work on sketch card sets?*
A They find us. We also go to cons and look for artists there as well. When I do sketch cards though, like for *GPK* and *Marvel Legends,* I only use artists who were published doing the comic books or worked on the characters themselves.

Q *How do you recommend new artists approach you?*
A Have examples of properties we work on and try to show what your standard card will look like. If you show painted cards as examples and only hand in very loose sketches when you're hired, the editor may not trust you for future projects.

Q *Do you prefer to find artists online or in person?*
A Doesn't matter as long as we see what we're going to get.

Q *What do you look for in an artist's portfolio?*
A Someone who can fill the card up with great art. But mostly someone who likes drawing and it shows on the cards.

Q *Can you offer any advice to aspiring sketch card artists?*
A Try to come up with your own style. Sometimes those manga-type cards start to look all the same, and a lot of people seem to be able to draw in that style. Even drawing straight-on portraits gets boring after awhile. Remember that sketch cards are not necessarily published artwork and all of them shouldn't be considered professional commercial art. It's a great start for lots of wannabe artists (like me), but should not be confused with real commercial art. In other words, just because you can draw a Spider-Man sketch card doesn't necessarily mean you could draw comics. I think some newcomers fool themselves and get hurt in the process when looking for real professional work. So keep that in mind when you get your first sketch card break.

News and Events
It's important to keep a regularly updated News section on your website. Include information about your latest art, what conventions and events you are attending, your latest achievements as an artist—anything relevant to you as a sketch card artist.

Links
Make sure you include links to help people find you elsewhere on the Internet: Facebook, Twitter, YouTube, deviantART or your blog. Most of these social networking sites have badges or logos available that you can place on your website as links.

Gallery and Videos
Visuals are the key to keeping the viewer interested. Definitely include a gallery for your artwork examples and photographs. If your website has the ability to host videos, create a video page. If not, link to your YouTube channel. Whatever you have that makes you stand out from the rest, share it!

Social Networking

The most popular method used to create a presence on the Internet is social networking. Social networks such as Twitter, Facebook, deviantART and YouTube allow users to create profiles and share all sorts of information with other users. There are many social networking sites out there, but we're going to focus on the ones most used by artists for promoting themselves.

As you build your career as a professional artist, it's a good idea to invest the time and effort in an official website. This will ensure that anyone who wants to has the ability to access all your information.

Building Your Network

The easiest way to build up your network is to populate your email contact list. Most sites prompt you to import your contact list upon signing up for the service. They automatically search your contacts and match people who are already using the site. You can then go through and choose to friend or follow them.

Twitter

Twitter is a social networking and microblogging service that allows users to post 140-character messages called tweets that answer the simple question "What are you doing?" These messages display on your profile as well as on the profiles of your friends, or "followers." Twitter is a quick and efficient way to spread brief messages, news, links and images to large groups of people.

SYNC TWITTER AND FACEBOOK UPDATES

If you're on Facebook and Twitter and you would like to sync your status updates and tweets, search for the Twitter application on Facebook that will give you options in syncing your sites. If you find yourself tweeting a lot and you don't want all of your Twitter posts showing up on your Facebook pages, Facebook offers a wonderful application that solves that problem. Do a search for "selective twitter status" and install the application to your Facebook page. When you post to Twitter, simply end your tweet with #fb and it will send only these selected tweets to Facebook.

To connect with people on Twitter you can search for people by name, username, keywords, phrases and locations. Or simply click around other users' Twitter pages to find like-minded people. Connecting and sharing through Twitter is a great way to create buzz about yourself, showcase your art and websites, and connect

TRENDING TOPICS AND HASHTAGS ON TWITTER

Trending topics are the most tweeted subjects on Twitter at any given time. Hashtags are a way to tag the topic or subject that you're tweeting about to make it easily searchable by other users. Simply add the # symbol before the topic you'd like to connect your tweet to (e.g., #sketchcards, #marvel, #comicbooks).

with fellow artists and fans to learn about the latest trends and news in your industry.

Twitter can be accessed from your computer or mobile phone. There are countless applications available for download to help you maximize the way you use the service. These applications are constantly being invented and improved, so do your research to see what programs work best.

Facebook

Facebook is one of the most popular social networking sites on the Internet. It offers users the ability to create customized profiles and share info, photos and videos with other users.

For promoting yourself as an artist, it's best to set up an artist's fan page or group, something separate from your personal Facebook account. Through your fan pages and groups you can build a fan base and share your art, events and news about you as an artist. Include samples of your artwork, information for prospective clients and fans, and personal information on how to reach you—basically most of the information you include on your professional website modified to fit Facebook's format.

One great features of a Facebook group is the ability to message all fan members at once. These messages go directly to the inboxes of fans instead of to their profiles where the messages might get overlooked.

deviantART

deviantART is an online community geared specifically towards user-created art. It's made up of more than fourteen million members including artists, art appreciators and art collectors. It's a terrific place to showcase your art, communicate with fans through messaging or live chat, and meet other artists in your industry. Art directors regularly use deviantART to scout artistic talent for upcoming sketch card sets and projects. The site also offers cool art contests and has a shop feature where you can sell your artwork.

deviantART tracks page views of specific pieces of art you've posted to gauge their popularity among your friends and fans. There is no limit to the amount of

SHORTEN YOUR LINKS BEFORE SHARING ON TWITTER OR FACEBOOK

Long links look messy, are hard to read and may not fit in the 140-character limit of Twitter. Use URL shortening programs like bit.ly or TinyURL to abbreviate your long links into fewer characters.

STAY UPDATED!

To keep your audience coming back, constantly update your website and social networking accounts with fresh information and photos. Each visit should be unique and memorable to the visitor. Just be yourself and share what makes you different from the rest and your website will stand out!

artwork you can upload. You can even create your own professional portfolio to submit your work for potential employers (http://portfolio.deviantart.com).

YouTube

YouTube is another wonderful platform for artists. It's a popular video-sharing community that allows users to create a channel (profile) and upload user-created videos. On your channel you can show how you create your artwork, introduce yourself in a fun, creative set-

ting, and exhibit your art skills to artists and fans all over the world.

To search and watch other users' videos, you can browse through categories, search by keyword or check out the most popular videos of the day. If you find a video you like, you can subscribe to that user's channel and be notified when they add a new video. This builds community and keeps you connected with artists you admire.

INCLUDE YOUR WEB ADDRESS EVERYWHERE

No matter where you post information about yourself—website, blog, Twitter, Facebook, deviantART—make sure your fans can easily link to your other website and accounts throughout the Internet. Think of it like leaving a trail of bread crumbs, where the destination is you and your artwork.

CREATE A STEP-BY-STEP VIDEO FOR YOUTUBE

Introduce fans and artists to your work by posting a how-to video showing how you create your artwork. Artists love to learn the processes of other artists. Be sure to choose proper keywords and tags so your videos are easily searchable.

Q *What is your position at Topps?*

A My official title is editor. However, while many of my duties do fall into that category, most of my job consists of art direction. I also do a decent amount of design work and some writing.

Q *How long have you worked there?*

A About six years at Topps, four years in this particular position.

Q *What was the first sketch card set released by your company?*

A *Marvel Legends* in 2001.

Q *What sketch card sets have you worked on?*

A Aye … *Transformers, Star Wars 30th Anniversary, Heroes, Halo, Star Wars: The Clone Wars, Heroes Volume 2, Indiana Jones: Heritage, Indiana Jones and the Kingdom of the Crystal Skull, Indiana Jones: The Masterpieces, Lord of the Rings: Masterpieces II, Star Wars Galaxy 4, Star Wars: The Clone Wars Widevision, Star Wars Galaxy 5, The Empire Strikes Back 3D Widevision.*

Q *How do you find new artists to work on sketch card sets?*

A A few different ways. Sometimes I'll get art sent to me that I like or I think could work. A lot of times unsolicited work is not very good. Those are the people who are most persistent. I also keep abreast of what different comic artists are doing, as it's nice to have some bigger names attached. Additionally, I browse a lot of art blogs to find people. Comic cons, deviantART and illustration magazines are all useful tools as well.

Q *How do you recommend new artists approach you?*

A Be humble, be professional and keep your samples good and tight. Usually sending fifty sketch cards you drew at home is going to hurt you, not help you. Normal-sized illustration is OK, too. Not everything needs to be sketch cards. Just because you can draw something that vaguely resembles Darth Vader with a pack of markers you bought at 7-Eleven doesn't mean you're the next big thing.

Q *Do you prefer to find artists online or in person?*

A As long as the work is good, on time and they're professional, they could float up on a raft of blue cats for all I care.

Q *What do you look for in an artist's portfolio?*

A Overall? Quality and creativity. I look for a good line—that tells me a lot. If a guy (or a girl) has a good strong line, they can do quick sketches that can blow a fully rendered painting out of the pool. I think that's one thing collectors need to learn: color does not always equal quality. I like comic art a lot. I also am really into Art Nouveau, pulp and old advertising art. Anything like that is what I notice first. I always balance it with straight photorealism because fans love that.

Q *Can you offer any advice to aspiring sketch artists?*

A Keep drawing. You may think you're good enough, but that's usually not the case. Also, even though the pay is not spectacular, these cards are a representation of you and your work and your name. Show a little pride—two thousand screaming monkeys isn't going to make anyone happy, least of all me.

Blogging

Blogging is an effective way to build a presence on the Internet and create a buzz about you and your art. An artist's blog is easy and free to set up and gives you a space to share your latest work, discuss new projects you're working on, or write about other artists who inspire you. Blogging is like a long version of Twitter—there is no limit to what you can write or post. You can interview fellow artists, cover current events in your industry, share techniques and bits of your creative process, or simply provide links to other interesting news, art and videos around the Internet.

When deciding on a title for your blog, be sure it best illustrates who you are and what you are writing about. A strong title will boost traffic to your blog, so make it short, sweet and to the point!

Free Blogging Tools

There are many free, easy-to-use blogging clients available. Ask around the art community and see what other artists prefer. A few examples are WordPress, Blogger and LiveJournal.

Custom Theme Pages

Customize your blog in a way that shows off your unique personality and your artistic flair. There are many different gadgets you can download right to your blog to link to your other websites such as Facebook, Twitter and your deviantART gallery. These gadgets can help you increase your blog exposure while promoting your work on other sites at the same time.

Sharing Photos and Videos

Everyone loves photos! No matter what you decide to blog about, sharing visuals is the best way to catch people's attention. Make sure you have something specific to show or tell people. Through different mobile apps, you can even upload photos from your phone or computer directly to your blog. Do you have an interesting, unique story to share about a new technique you're doing to create a sketch card? Get creative and blog away.

All of these social networking sites offer you exposure, unique promotional tools, valuable information and networking opportunities in different settings. The more you post on these sites, the more exposure you will have, and the more people will discover you!

Comments

Be sure to allow all of your visitors the ability to leave comments. This way you can interact directly with your fans. You can customize your comments so that you can moderate the comments before posting them.

Remember, everything you post on the Internet is a reflection of your character and who you are. Be professional, but be yourself. Keep your posts honest, friendly, positive, fun and interesting.

BLOGGING ON THE GO

If you have a smartphone or iPhone, blogging on the go is a great way to share information whether you're in the studio, at a convention or traveling. Research the different applications you can download to your mobile device for WordPress or Blogger.

Q *How long have you worked at 5FINITY?*

A Since our inception in March 2009.

Q *What was the first sketch card set released by your company?*

A A sketch card series benefiting March of Dimes featuring Archie Comics and Teenage Mutant Ninja Turtles was our first release.

Q *How many artists are on your roster?*

A Well over two hundred.

Q *How do you find artists to work on sketch card sets?*

A We use artists that work on the particular properties in an official capacity, like Archie Comics artists for the Archie sketch cards and Mirage Studios artists for the Teenage Mutant Ninja Turtles sketch cards. But, we also proactively recruit new talent and encourage artists to submit samples to us directly. We also use the many great sketch card artists that have worked for the other companies, of course, as well as artists from the comic book and animation communities.

Q *How do you recommend new artists approach you?*

A Getting in touch with us via email is the easiest way.

Q *Do you prefer to find artists online or in person?*

A Online gives us more accessibility, but in person is fine, too. We do not set up at conventions nearly as much as we check our email.

Q *What do you look for in an artist's portfolio?*

A It is important that the artist fits the style of that particular sketch card project. Someone can have great manga skills for something like *Voltron*, but isn't so good at monsters, for example. It goes without saying that the artist needs to be pretty good since the sketch card market is very competitive. Unfortunately, there are not enough slots to go around for all of the artists that want to work on any given series.

Q *Can you offer any advice to aspiring sketch card artists?*

A Get your work out there, especially online, where art directors recruit new talent. Definitely contact the companies directly and show them samples. We are proud at 5FINITY that we have utilized the talents of many artists that have never worked on sketch cards and have become fan favorites. It is a cool thing.

Forums

Forums are where you can make a name for yourself in the industry by contributing to topics that interest you. You can also look for potential work opportunities and find out what events are coming up that might interest you.

A great forum for sketch card artists is the Scoundrel Art Community Forums (http://scoundrelpublishing.com/spart/index.php). To contribute, create a profile with your photo or avatar. You can use your real name, which we recommend if you plan to contribute as a professional artist, or an alias. The benefit to using your real name is that you can link to your website and your blog in your signature. Using your real name also makes you more searchable in search engines like Google and Yahoo!

Just like blogging and Twitter, when you post regularly to forums, you increase your exposure as a sketch card artist. Forums usually have a place for new members and artists to introduce themselves. Go ahead and post a topic saying you are new to the forum and share a little about yourself and your art. Forums are an opportunity to join in on discussions happening in the art community. You can even start discussions about a piece you're creating, promote artwork you have for sale, share information about your favorite mediums and talk about upcoming events you're participating in.

Forums are great places to learn about your industry and to find out who's looking for artists and what events are coming up that might interest you. The best way to find out what's happening in your industry is to do your homework, so take your time and browse through the forums.

SKETCH CARD FORUM

SKETCH CARD MANIA
I don't know about you guys, but I love Sketch Card Mania. I was always wishing I could learn how to make my own sketch cards. Now, thanks to Randy and Denise, I am making some really great cards.

Re: SKETCH CARD MANIA
Oh yeah, I'm loving it. They really explain how to get into the industry of sketch cards, too. It really helps to let aspiring artists know how to reach art directors like me. BTW, I've seen your sketch cards lately, and I have to say, great work! How would you like to do some cards for my company?

Re: SKETCH CARD MANIA
I am so happy you like our book. We really wanted to help artists learn the basics of how to make their own sketch cards and get out there! Thank you both for reading.

Re: SKETCH CARD MANIA
Thank you to both of you. We put a lot of hard work into the book. I'm glad you guys are diggin' it. Sketch cards are pretty cool. Can you believe all the different shapes and sizes they are now?

Q *How long did you work at Upper Deck?*
A Nine years.

Q *What sketch card sets have you worked on?*
A MM1, 2 and 3

Q *How many artists were on your roster?*
A For sketch cards, probably about 250. In general, well over three thousand.

Q *How do you find artists to work on sketch card sets?*
A Having worked in the comic industry for about twenty years, I usually work with the pros I know first. They often recommend others, and I meet folks at conventions, that sort of thing. I also check out the different sketch card sites and approach those people, and also look for artists on deviantART.

Q *How do you recommend new artists approach you?*
A Best bet is to email me samples of your work with all your contact information.

Q *Do you prefer to find artists online or in person?*
A Online for the most part. I am so busy that conversations have become a luxury; much easier for me to get my job done via email than on phone or in person.

Q *What do you look for in an artist's portfolio?*
A Style, professionalism, anatomy, design, etc.—and not necessarily in that order.

Q *Can you offer any advice to aspiring sketch card artists?*
A Be creative in the small window sketch cards afford you.

PRO TIPS | Nathan Ohlendorf, Founder and
President, Sadlittles Trading Cards

Q *What is your position at Sadlittles?*
A President, editor, artist, mail room, janitor … and lunch lady.

Q *How long have you worked there?*
A It has been a year from starting production of *Legends & Lore* to five projects we have going now.

Q *What sketch card sets have you worked on?*
A *Justice League of America Archives*, *Voltron* and *Legends & Lore*. A few other miscellaneous fill-in jobs, too.

Q *How many artists are on your roster?*
A I work with sixty plus artists and it is growing every day.

Q *How do you find artists to work on sketch card sets?*
A I collect sketch cards so I usually just email who I like. Some people contact me and I usually am like ''Whoa! Is this a joke? Randy Martinez is emailing me?! No way! Cool!''

Q *How do you recommend new artists approach you?*
A Just email me via the website. I may not respond right away, but I look at all art and read every email.

Q *Do you prefer to find artists online or in person?*
A I'm new to the convention thing, so online is where I look the most.

Q *What do you look for in an artist's portfolio?*
A Most people say talent, but that is only secondary to work ethic. I need people who will meet a deadline and respond to an email. If you can't finish a commission on time, then how are you going to handle a fifty- or one-hundred-card deadline?

Q *Can you offer any advice to aspiring sketch card artists?*
A Keep drawing. Somebody will buy your stuff especially if they will buy my crap.

The Prepared Artist

Here is a profile of a typical artist out on the hunt for great art opportunities. Confidence and a positive attitude are a must for the prepared artist when getting your name out there and looking for work.

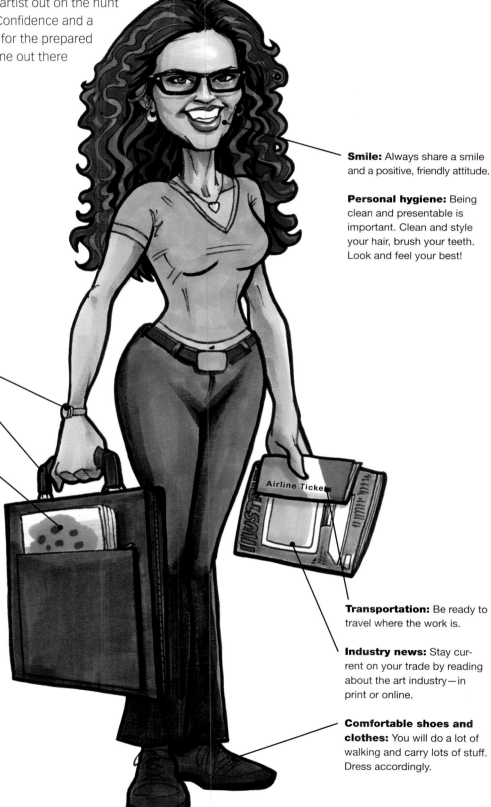

Business cards: Carry business cards to hand out to prospective employers, clients and fans.

Organizer: Keep track of scheduled appointments or meetings. Digital organizers such as your mobile device or a notebook also work well.

Watch: Be on time or even a little early!

Portfolio: Fill this with your best new and most relevant work for the jobs you want.

Sample art: Carry with you printed copies of art to leave with potential clients or contacts.

Folder: You'll need some way to collect business cards and organize all the information you gather from clients and contacts you meet along the way.

Smile: Always share a smile and a positive, friendly attitude.

Personal hygiene: Being clean and presentable is important. Clean and style your hair, brush your teeth. Look and feel your best!

Transportation: Be ready to travel where the work is.

Industry news: Stay current on your trade by reading about the art industry—in print or online.

Comfortable shoes and clothes: You will do a lot of walking and carry lots of stuff. Dress accordingly.

Q *How long have you worked at Rittenhouse?*
A Nine years.

Q *What sketch card sets have you worked on?*
A All of the trading card sets that Rittenhouse Archives has produced that have had sketch cards. This not only includes our Marvel and DC sets, but also *Farscape*, *Stargate*, *Star Trek*, *Conan*, *Xena* and *Munsters*.

Q *How many artists are on your roster?*
A We have a list of almost 150 artists that have done sketch cards for us over the ten years the company has been in business.

Q *How do you find artists to work on sketch card sets?*
A I first started by contacting some artists that I personally knew and that I knew had done sketch card work in the past. I then brought on board several artists that I met at various conventions. From there, word of mouth and artists recommending other artists allowed us to greatly expand our roster of some very talented artists.

Q *How should new artists approach you?*
A Artists interested in becoming a sketch card artist for Rittenhouse Archives should send their submissions to artsubmissions@scifihobby.com.

Q *Do you prefer to find artists online or in person?*
A Walking around a convention floor and going through an artist's portfolio and getting a chance to speak with them directly is always my preferred method. However, it is also exciting to receive an email with sample work that just completely blows me away.

Q *What do you look for in an artist's portfolio?*
A I first look for uniqueness in the artistic style and then for character likeness. Attention to detail always catches my eye. For example, adding a prospective skyscraper in the background to complete a city skyline shows that extra step of attention that I like. Adding background to a card gives it depth, and drawing the character in an action pose gives a sense of motion to the overall piece.

Q *Can you offer any advice to aspiring sketch card artists?*
A Be yourself and don't try to duplicate the style of other artists or what you see in the comic books.

LANDING A SKETCH CARD JOB: START TO FINISH

1 A sketch card producer contacts you to participate on a set of sketch cards.
2 You correspond with the art director to determine what is expected of you, how many cards you will complete, when the deadline is and your fee.
3 The art director sends you a package that includes your agreed number of official blank sketch cards, your agreement/contract and instruction on how to return the completed cards. (Note: This cost should be covered by the card company.)
4 You complete all of the sketch cards you agree to do.
5 You carefully package up your sketch cards, complete with your signed agreement, and mail the cards with an invoice for your services.
6 Get paid! Most companies pay 30 or 45 days after you return your cards and an invoice.
7 Promote your work. Post and promote the official art you have done. It will gain you credibility and appreciation from fans when you show off your official work.

WHAT TO DO WHEN YOU LAND A SKETCH CARD OPPORTUNITY

Sketch cards are a great stepping stone to the illustration industry. Always weigh the pros and cons of each job you are offered and decide if it's best for your career. Here are some good questions to ask the art director when they contact you about a job:

1 **What is expected of me?** Do you have to do full color sketches, or is a simple black-and-white sketch enough?

2 **What is the deadline?** Knowing the deadline will help you decide how many cards you are able to do. Sometimes deadlines are very short, and you have to be honest whether or not you have time to do the job you are hired to do.

3 **How much will I be paid per card?** This is a question many new artists are afraid to ask for some reason. Drawing sketch cards is a job just like anything else, so you need to get paid fairly. The sad truth is sketch cards do not pay much, usually $1.50 to $6.00 per card. Full-color cards usually pay more than black-and-white cards, but adding color takes a lot more time. You have to decide if the money is worthy of the time you will spend on the cards.

4 **What incentives are offered?** While the pay per card is not great, some companies offer other incentives. Certain sets come with the incentive of big exposure. *Star Wars*, Marvel Comics and *Lord of the Rings* will get you a lot more exposure than a lesser-known title. Many companies offer *comp boxes* of the set you worked on. A comp box is a complimentary sealed box of the trading card product you worked on. Comp boxes are fun to open. You might find another artist's sketch card or even one of your own. Some artists sell their comp boxes for extra cash.

The most sought-after incentives are *artist returns* or *artist proofs*. Artist return cards are completed sketch cards chosen by the artist that are returned to said artist. The artist can sell these cards or keep them. Many artists choose to make their return cards special and different than the cards done for "pack pulls." Artist return cards can sometimes demand a premium price tag. Artist proof sketch cards are blank sketch cards specially stamped as artist proofs. Artist proofs are special because fans can commission artists to illustrate specific requests on the blank card after the set has been released.

5 **When do I get paid?** The most common pay schedule is 30 days after your cards have been received and an invoice is received. You should get paid regardless of the product's release status. Some companies pay 30 days after the release of product. Accept these agreements at your own risk. This pay schedule means you will not get paid until the product is released. If the product is delayed, your paycheck is delayed; if the product never gets released, you never get paid. It's something to think about.

6 **Is shipping paid for by the card company?** All shipping expenses should be covered by the company that hires you.

7 **When can I post my cards?** You want to be able to start promoting the work you are doing as soon as possible. Some companies do not want you to post sets early because of licensing agreements or secrecy. Capitalize on the fact that you are doing official work, and promote it as best you can.

Sketch Card Resources

companies

Topps Trading Cards (www.topps.com): Sketch cards for Star Wars, The Lord of the Rings, Indiana Jones, Terminator, Garbage Pail Kids, baseball and WWE.

Upper Deck (www.upperdeck.com): Sketch cards for Marvel Masterpieces. Acquired Fleer/Skybox.

Rittenhouse Archives (www.scifihobby.com): Sketch cards for Marvel Comics, Star Trek, DC Comics and Conan.

Sadlittles (www.sadlittles.com): Sketch cards for Legends & Lore, Essence of Fairyland, Damsels & Dinosaurs and Dreamers of Darkness.

5FINITY Productions (www.5finity.com): Sketch cards for Zombies vs. Cheerleaders, Teenage Mutant Ninja Turtles, Archie Comics, Voltron and Moonstone Books.

Artbox (www.artboxent.com): Sketch cards for Frankenstein. Also publish Harry Potter cards.

Breygent Marketing (www.breygent.com): Sketch cards for Dexter, The Wizard of Oz, Marilyn Monroe, The Three Stooges, classic movies and cartoons.

websites

deviantART (www.deviantart.com): Online community for artists to share their work. Editors and art directors frequent this site looking for artists for sketch cards.

Scoundrel Art Community (www.scoundrelpublishing.com/spart/index.php): Forums for sketch card artists to discuss and share their work.

Beckett Media (www.beckett.com): The source for all sports cards and artist sketch card encapsulation.

Non-Sport Update (www.nonsportupdate.com): The magazine for collectors of non-sport cards.

Sketch Collectors (www.sketchcollectors.com): A space for sketch card artists to display their work and organize their collections.

SketchCards.com (www.sketchcards.com): Information and resources on the top sketch card artists and series, with links to purchasing cards.

ComicSpace (www.comicspace.com): A social networking site for comics creators and fans. The site includes a service to post WordPress blogs and web comics.

Sketchcards.org (www.sketchcards.org): A gallery of sketch card collections spanning dozens of card series from the top card companies.

World Famous Comics (www.worldfamouscomics.com): An archive of columns and articles relating to comics. It includes lists of art contests.

Comic Related (www.comicrelated.com): Community forums for comics and sketch card artists and fans.

supplies

BCW Supplies (www.bcwsupplies.com): Online store for card collecting accessories and supplies, including sleeves, top loaders, binders and hard cases.

Ultra Pro Supplies (www.ultraprosupplies.com): Online source for card protection supplies.

Blue Line Pro (www.bluelinepro.com): Sketch card drawing supplies.

GALLERY

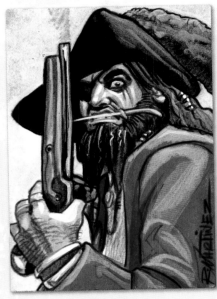

PIRATE
Sketch card by Randy Martinez

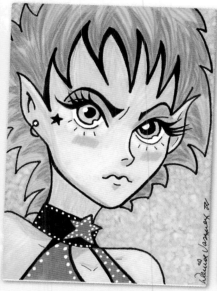

ROCKER MANGA
Sketch card by Denise Vasquez

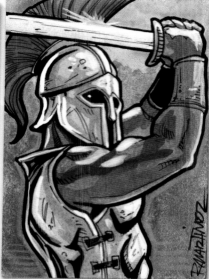

ACHILLES
Sketch card by Randy Martinez

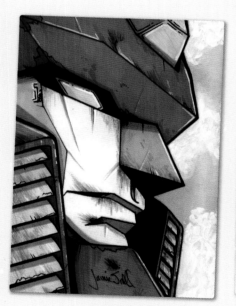

CECE CARD
Sketch card by Jamie Snell

SILVERFISH
Sketch card by Luis Diaz

SURFER
Sketch card by Randy Martinez

ECLIPSE
Sketch card by Randy Martinez

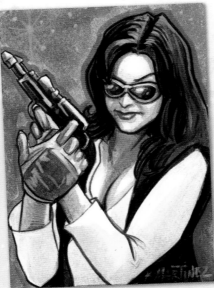

SPACE PIRATE GIRL
Sketch card by Randy Martinez

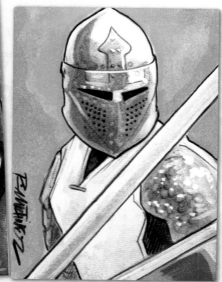

KNIGHT
Sketch card by Randy Martinez

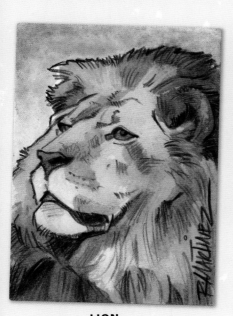

LION
Sketch card by Randy Martinez

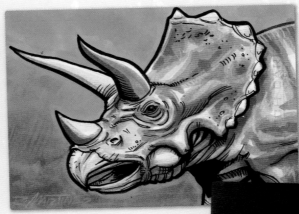

TRICERATOPS
Sketch card by Randy Martinez

CAPTAIN HOPE
Sketch card by Denise Vasquez

SHARK
Sketch card by Randy Martinez

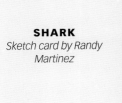

LOCH NESS
Sketch card by Ingrid Hardy

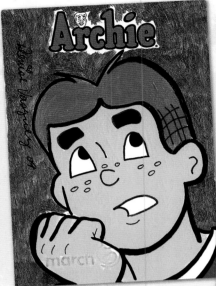

ARCHIE
Sketch card by Denise Vasquez

ARCHANGEL MICHAEL
Sketch card by Terese A. Nielsen

NERDY BIRD
Sketch card by Randy Martinez

WOODSTOCK
Sketch card by Denise Vasquez

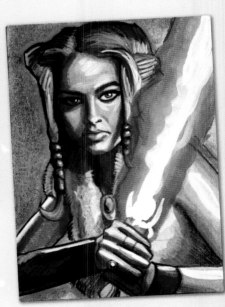

FIRE SWORD
Sketch card by Randy Martinez

HOLLYWOOD
Sketch card by Randy Martinez

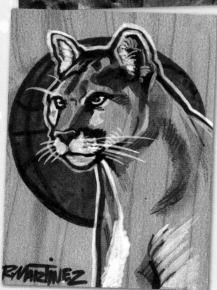

COUGAR
Sketch card by Randy Martinez

LION JEDI
Sketch card by Randy Martinez

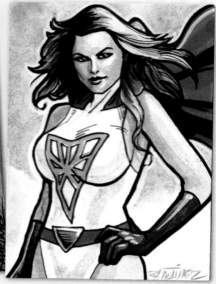

HERO GIRL
Sketch card by Randy Martinez

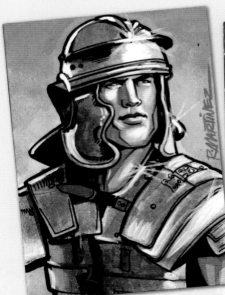

ROMAN
Sketch card by Randy Martinez

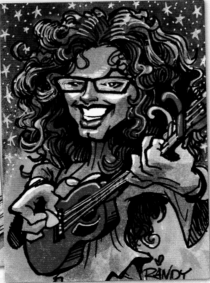

DENISE
Sketch card by Randy Martinez

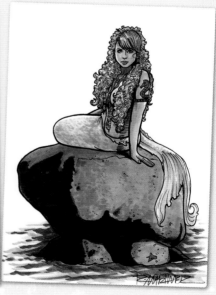

MERMAID
Sketch card by Randy Martinez

Last Words

We hope you have enjoyed *Sketch Card Mania*. It was our goal to not only teach you the basics of how to make your own sketch cards, but also to inspire you to take your sketch card art to the next level. You can create sketch cards as a hobby or make them as gifts. You can seek out groups where you can meet other artists, and create and trade sketch cards. You might even have an interest in becoming a professional sketch card artist.

Remember that becoming a professional sketch card artist takes hard work and lots of time—the industry is very competitive. Don't let that discourage you. The journey along the way, filled with all of your accomplishments and growth, is the best part of living the dream.

So whether you are pursuing a career in the sketch card industry or just want to make sketch cards for fun, use these fundamentals as a foundation to create great-looking sketch cards. Always continue to push yourself as an artist and try out new art materials, styles and techniques. The only limits you have are the limits of your imagination.

www.sketchcardmania.blogspot.com

Best Wishes,

Denise Vasquez and Randy Martinez

TIPS FOR BREAKING INTO THE BUSINESS

- Be professional. Treat people with respect.
- Create opportunities for yourself. Don't expect jobs to come to you.
- Be patient. Building your reputation as a talented and reliable artist takes time.
- Follow up on jobs in a timely fashion.
- Be realistic about how much work you can take on at one time.
- Keep your portfolio updated.
- Go to conventions and introduce yourself to other artists.
- Maintain a strong work ethic. You must continuously work on your craft.
- Stay up-to-date with industry news.
- Join and contribute to industry forums.

ACKNOWLEDGMENTS

To my "Nani" Glenda Perez. You have been such a positive influence on my life and the best role model any daughter could ever have. Thank you for always loving and supporting me in every way and for showing me that anything is possible if you work hard, stay positive and believe. —*Denise*

To our families "Papi" Rafael Perez, "Yaya" Margarita Perez, "Titi" Margarita Perez, Mom, Tina and Guillaume Camus, Danny and Denise Martinez, Cory, Lucca and Lola, Barbara McDonald, Melissa Suther and family for your continuous love and support. —*Randy*

To Sarah Laichas and Mona Michael. Thank you for all of your guidance.

To Tish Ciravolo and Daisy Rock Guitars, for all of your support.

To Steve Sansweet, for your continuous support and amazing friendship.

Also thanks to IMPACT Books, Lucasfilm Ltd., Meagan Finnerty, Josh Kushins, Chris Holm, Dan Smith, Marvel, Carol Pincus, Jesse Falcon, Universal, Ed Prince, Kim Niemi, NBA, NBA Players Association, MLB, MLB Players Association, Topps Trading Cards, Jeff Zapata, David Waldeck, John Williams, Rittenhouse Archives, Robert Kohlbus, Tom Breyer, Breygent Marketing Inc., UpperDeck, Mark Irwin, Scott Gaeta, Nathan Ohlendorf, Sadlittles, Archie Comics, Steve Frank and 5FINITY Productions.

To Justin Lubin. Thank you for sharing your amazing gift of photography.

To Mark Anderson, Beckett Media. Thank you for the Artist Sketch Card Encapsulations.

Thank you to all the contributing artists—Mark McHaley, Matt Busch, Luis Diaz, Leah Mangue, Nicole Falk, Soni Alcorn-Hender, Terese Nielsen, Alex Alderete, Ingrid Hardy, Jamie Snell, Len Bellinger and Jeff Chandler. Special thanks to our creative friends: Nerdy Birds Art Nest, WO+MEN 4 A CAUSE, Michelle Smart, Sakura of America, Julia Reed, Leslie Crumpler, HK Holbein Inc., Timothy S. Hopper, Matt Hopper, Prismacolor, Ben Goss, Sarah Jo Marks and Dov Kelemer, Harris Toser, *Non-Sport Update*, Leslie Combemale, Steve Anderson, Angie Riemersma, The Forcecast, all of our friends and fans for their continuous support, Twitter, Facebook, MySpace, deviantART, YouTube, Scoundrel, Comic Con International, Dragon Con, Jedi Con, Star Wars Celebration, Brian and Shelley Ehler family, Aunt Linda and the Moran cousins.

Other fine IMPACT Books are available from your local bookstore, art supply store or online supplier. Visit our website at www.fwmedia.com.

15 14 13 12 11 5 4 3 2 1

DISTRIBUTED IN CANADA BY FRASER DIRECT
100 Armstrong Avenue
Georgetown, ON, Canada L7G 5S4
Tel: (905) 877-4411

DISTRIBUTED IN THE U.K. AND EUROPE BY F+W MEDIA INTERNATIONAL
Brunel House, Newton Abbot, Devon, TQ12 4PU, England
Tel: (+44) 1626 323200, Fax: (+44) 1626 323319
Email: postmaster@davidandcharles.co.uk

DISTRIBUTED IN AUSTRALIA BY CAPRICORN LINK
P.O. Box 704, S. Windsor NSW, 2756 Australia
Tel: (02) 4577-3555

Edited by **Sarah Laichas**
Designed by **Wendy Dunning**
Production coordinated by **Mark Griffin**

About Randy Martinez

Randy Martinez was born and raised in Southern California, the son of two artists. He got his first art-related job at age sixteen as a caricature artist at Six Flags Magic Mountain. After a short basketball career at California Lutheran University, Randy received a bachelor of fine arts in design and illustration from Kansas City Art Institute. He then moved back to California to pursue a professional art career.

Randy became an officially licensed artist for Lucasfilm Ltd. in 1999 when he started drawing gag cartoons for *Star Wars Kids* magazine. In 2002, he began drawing sketch cards for Topps Trading Cards and has since drawn over 10,000 official cards for *Star Wars*, *Lord of the Rings*, *Heroes*, *Terminator* and Marvel Comics.

Other sketch card and illustration clients include LucasArts, Inkworks, Red 5 Comics, Playroom Entertainment, Rittenhouse Archives, Breygent Marketing, Sadlittles, 5FINITY Productions, Wintner Artist Management, IDG Entertainment, Paizo Publishing, Guitar Center, Green Ronin Publishing and LifeForce Indie Films Entertainment. He's been published in the magazines *Star Wars Insider*, *Star Wars Kids*, *Cracked*, *GAG!*, *Undefeated*, *Dragon*, *Amazing Stories*, *Journal of the Whills* and *Cinescape*, as well as in the *Los Angeles Times* and the *Ventura County Star*.

He is perhaps best known for illustrating the key art for *Star Wars Celebrations IV* and *V* and *Star Wars Celebration Europe*. Other *Star Wars* illustration credits include art for starwars.com, prints for Acme Archives Direct, book covers for Scholastic, key art for JEDI-CON 2010.

Randy's first IMPACT Book, *Creature Features: Draw Amazing Monsters & Aliens*, came out in 2009. Visit his website at www.randymartinez.net.

About Denise Vasquez

Denise is a professional artist whose talents range from award-winning singer-songwriter, guitarist, activist and actress to published writer, photographer, poet and freelance journalist for the Examiner.com.

Denise has illustrated hundreds of sketch cards for Topps including *Star Wars*, *The Clone Wars*, *Indiana Jones* and *Terminator*. Other sketch card work includes *Zombies vs. Cheerleaders*, the Woodstock poster series for Breygent Marketing, Comics for Cures to benefit the American Cancer Society, the Pediatric Oncology Treasure Chest Foundation, and the 5FINITY Productions Archie Comics/March of Dimes series. Denise has also collaborated on Marvel and X-Men sketch cards for Rittenhouse Archives. In addition to sketch cards, Denise has designed and illustrated T-shirts, CDs, logos, music posters, flyers, 3-D art and custom vinyl toys working for clients such as Lucasfilm, Stan Lee, 501st Legion, DKE Toys and World View Graphics.

Since 1999, Denise has worked with WO+MEN 4 A CAUSE, an organization she founded to raise awareness for different causes and help those in need. Denise has also received numerous awards and nominations for her three self-produced record albums. She is currently working on her fourth album, *Life Happens*.

Denise proudly incorporates all of her experiences as an activist, artist, actress, dancer, singer, writer and photographer into her life as well as her art. She currently resides in Los Angeles, California. Visit her website www.denisevasquez.com.

Index

METRIC CONVERSION CHART

To convert	to	multiply by
Inches	Centimeters	2.54
Centimeters	Inches	0.4
Feet	Centimeters	30.5
Centimeters	Feet	0.03
Yards	Meters	0.9
Meters	Yards	1.1

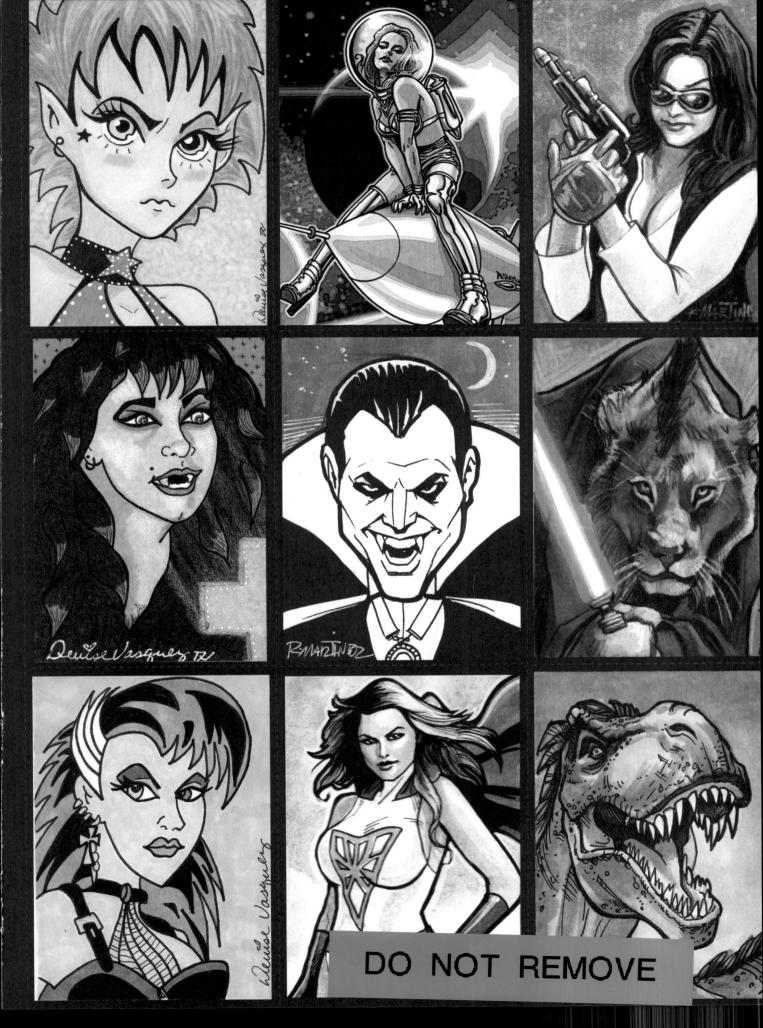

DO NOT REMOVE

Sketch Card MANIA

How To Create Your Own Original Collectible Trading Cards

www.impact-books.com

http://sketchcardmania.impact-books.com

www.sketchcardmania.blogspot.com

Sketch Card MANIA

How To Create Your Own Original Collectible Trading Cards

www.impact-books.com

http://sketchcardmania.impact-books.com

www.sketchcardmania.blogspot.com

Sketch Card MANIA

How To Create Your Own Original Collectible Trading Cards

www.impact-books.com

http://sketchcardmania.impact-books.com

www.sketchcardmania.blogspot.com

Sketch Card MANIA

How To Create Your Own Original Collectible Trading Cards

www.impact-books.com

http://sketchcardmania.impact-books.com

www.sketchcardmania.blogspot.com

Sketch Card MANIA

How To Create Your Own Original Collectible Trading Cards

www.impact-books.com

http://sketchcardmania.impact-books.com

www.sketchcardmania.blogspot.com

Sketch Card MANIA

How To Create Your Own Original Collectible Trading Cards

www.impact-books.com

http://sketchcardmania.impact-books.com

www.sketchcardmania.blogspot.com

Sketch Card MANIA

How To Create Your Own Original Collectible Trading Cards

www.impact-books.com

http://sketchcardmania.impact-books.com

www.sketchcardmania.blogspot.com

Sketch Card MANIA

How To Create Your Own Original Collectible Trading Cards

www.impact-books.com

http://sketchcardmania.impact-books.com

www.sketchcardmania.blogspot.com

Sketch Card MANIA

How To Create Your Own Original Collectible Trading Cards

www.impact-books.com

http://sketchcardmania.impact-books.com

www.sketchcardmania.blogspot.com